The Nineteen Twenties Style

The Nineteen Twenties Style

Yvonne Brunhammer

Paul Hamlyn

LONDON · NEW YORK · SYDNEY · TORONTO

Translated by Raymond Rudorff from the Italian original

Lo stile 1925

© 1966 Fratelli Fabbri Editori, Milan

This edition © copyright 1969
THE HAMLYN PUBLISHING GROUP LIMITED
LONDON · NEW YORK · SYDNEY · TORONTO
Hamlyn House, Feltham, Middlesex, England

S.B.N. 600012247

Text filmset in Great Britain by
Keyspools Ltd, Golborne

Printed in Italy by
Fratelli Fabbri Editori, Milan

Contents

INTRODUCTION

The 20th century is one of accelerated change, with the result that the inter-war period already seems remote. A few years ago it seemed possible to define the style of the 1920s in a few words, and only recently has it begun to be interpreted in a less limited and conventional manner. Unbiased examination reveals an unexpected complex of related, interacting or opposing tendencies. It would be premature to believe that even the 'useful' arts of the period can be summed up once and for all, let alone in the few pages of this book; all that can be done here is to attempt to simplify some of its complexity and reveal its richness.

A first step towards better understanding of the period was taken at the exhibition 'Les Années '25' (1965) at the Musée des Arts Décoratifs in Paris. Although it was undoubtedly incomplete and unequal in quality, it was as impartial as possible,

rejected facile definitions, raised questions, and confronted contemporary, absolutely opposed styles. The title of the exhibition refers to the French term '1925 style', which itself derives from an earlier exhibition: the Exposition Internationale des Arts Décoratifs et Industriels Modernes, held in Paris in 1925. As a matter of fact, this exhibition was by no means fully representative of the modern movement. It included work by the architects Perret, Mallet-Stevens and Melnikoff, the painters Léger and Robert and Sonia Delaunay, the sculptors Laurens and Lipchitz, the interior decorators Pierre Chareau, Legrain, Jean Dunand and Jean Puiforcat, and Le Corbusier's and Ozenfant's Pavillon de l'Esprit Nouveau. But the artists of the Weimar Bauhaus and the Dutch De Stijl—movements absolutely decisive in modern design—were ignored.

Whether or not contemporaries realised it, however, the 1920s were a crucial period. On one hand, there was the pre-1914 world, which had experienced the war without, it appears, becoming aware of the profound changes caused by it; on the other, the new world of the second industrial revolution. On one hand, decorative art in the traditional sense (reserved for an élite, since every work was an original creation); on the other, an industrial art aimed at the largest possible public and planned by avant-garde artists.

ART NOUVEAU

The revolt against academicism and historicism in art and sheer ugliness in industrial design began in England. The poet and painter William Morris and the art critic John Ruskin took up arms against the quality and style of the industrial arts presented to the public in the great exhibitions in London (1851 and 1862) and Paris (1855 and 1867). Faced by objects that were nearly all 'of a pitiful and pretentious ugliness', Morris extolled the works of the Middle Ages 'in which everything made by the hand of man was more or less beautiful'. He preached the nobility of manual work and craftsmanship, and the necessity of creating everyday objects of beauty with one's own hands. Many young painters and architects worked with Morris to promote such an aesthetic and social renaissance, but none were entirely able to free themselves from nostalgia for the past—neither Morris nor Philip Webb (who with Richard Norman Shaw initiated the 'Domestic Revival', a movement devoted to the renewal of domestic architecture). There were similar aims behind the great French exhibitions of the second half of the 19th century and the foundation of the Union Centrale des Arts Appliqués à l'Industrie (1864) 'in order that the arts concerned with the pursuit of the beautiful in the useful should flourish'.

Art Nouveau entailed a revolution in the status of the applied arts, which were given equal ranking with the fine arts. To be more precise, Art Nouveau artists simply denied the validity of the distinction between 'fine' and 'applied'. The applied arts were certainly in need of serious attention from artists: late-19th-century pseudo-historical *pastiches* had begun to bore even the Philistine middle class, which was after all aware of living in a world that had been reshaped by industry. The lack of an appropriate setting for domestic and commercial life was widely realised, and the desire for a really new environment gave rise to an original decorative style. Although the movement did not spread to painting and sculpture, it shared its sources with them, deriving its naturalism from Impressionism and its mannerist aspect from Symbolism. It broke down the barriers between art and craftsmanship, with the result that painters like Bonnard and Toulouse-Lautrec designed posters, Gaugin made pottery, and so on.

The two men most responsible for bringing Art Nouveau into everyday life were Gallé and Bing. Gallé was the creator of subtly tinted glassware, often in exotic flower shapes. He was the head of a school which included artists as diverse as Daum, Victor Prouvé, Wiener, Vallin and Majorelle. In 1896 Bing, a dealer who specialised in Oriental

1. Léon Bakst. Scene from *Shéhérazade*. 1910. Water-colour (54.5 x 76 cms). Musée des Arts Décoratifs, Paris.

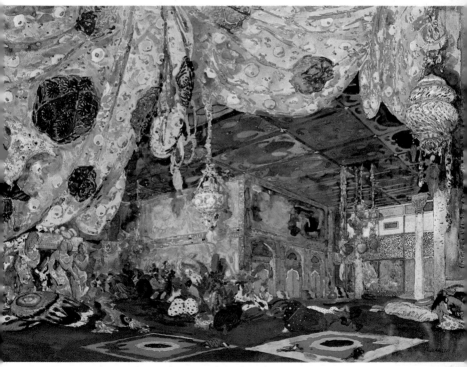

1. Léon Bakst. Scene from *Shéhérazade*. 1910. Water-colour (54.5 x 76 cms). Musée des Arts Décoratifs, Paris. © by SPADEM, Paris, 1967. Choreography by Michele Fokine, décor by Léon Bakst, with music by Rimsky-Korsakov. *Shéhérazade* was one of the Russian ballets presented by Diaghilev; the splendour of the colours and the harmony of décor, costumes and stage equipment was a complete revolution in theatrical tradition.

2. Henri Laurens. Model for a sculpture used in the set of *Le Train Bleu*. 1918. Terracotta (43.7 x 23.8 cms). Serge Lifar Collection. © by ADAGP, Paris, 1967. This 'operetta for dancing' by Jean Cocteau and Darius Milhaud had scenery by Laurens and costumes by Chanel. It was perhaps the most successful of Diaghilev's post-war experimental ballets.

3. André Marty. *A Party at Poiret's*. 1914. Water-colour. The artist's collection. The pre-war years were profoundly influenced by Poiret's designs for clothes and his splendid parties. This illustration is by André Marty, a skilful fashion draughtsman and illustrator.

2. Model for the set of *Le Train Bleu*. 1918.

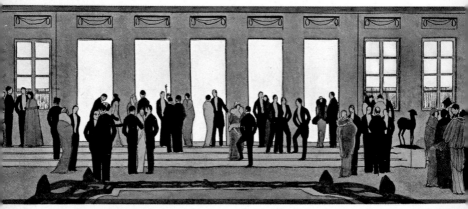

3. André Marty. *A Party at Poiret's.* 1914. Water-colour. The artist's collection.

antiquities, visited the United States, where he was deeply impressed by American architectural achievements and the work of the glass-maker Tiffany. When he returned, he made his shop a centre of modern art, calling it 'Art Nouveau'; artists from all countries met there. Bing achieved a synthesis of the arts, asking such painters as Bonnard, Lautrec, Vuillard and Grasset to make designs for stained-glass windows, and commissioning Tiffany to execute them. At the 1900 Exhibition, the Art Nouveau pavilion was designed by three artists who worked regularly for Bing, Eugène Gaillard, Colonna and Georges de Feure. It was an important propaganda gesture, excluding everything but work of the most thoroughgoing modernism.

Although Art Nouveau was essentially an attempt to integrate art into social life, it ended by seeming to be an exaltation of individualism and decoration for its own sake; even Guimard and Horta tended to sacrifice construction to decoration. A movement in opposition to Art Nouveau began in England, led by Charles A. Voysey, the precursor of a rational, stark style of architecture. Vienna was even more forward-looking. The Scottish Art Nouveau architect Charles Mackintosh had a success in Vienna in 1900; but this can be attributed to his sense of vertical lines and highly personal way of interpreting the curved

lines and colours of Art Nouveau. For it was in Vienna that a return to the straight line and the use of geometrical forms were proposed by Otto Wagner (an heir of Viollet-le-Duc) and his disciple J. M. Olbrich. In *Ornament und Verbrechen,* published in 1908, Adolf Loos attacked the 'ornamental delirium' of Art Nouveau even more violently, and championed a puristic, unadorned architecture. He provided an example two years later with the Steiner house, a concrete cube that was to inspire the De Stijl group, the Bauhaus, and L'Esprit Nouveau. At this time Josef Hoffmann achieved a synthesis of Wagner's principles and Art Nouveau in his Palais Stoclet (1905–1910) at Brussels.

In Germany, the theories of the architect Muthesius, who maintained that art cannot disassociate itself from the machine, were instrumental in the creation (1907) of the Werkbund, a society of industrialists and artists (Behrens, Hoffmann, Riemerschmid, Van de Velde) formed to 'co-ordinate efforts to achieve quality in industrial production, and to create a rallying-point for all who have the means and the will to make products of quality'. An ancestor of the Bauhaus, the Werkbund was to be fiercely opposed by the partisans of tradition when it became known in France.

The French reaction against Art Nouveau assumed

a technical aspect when Perret built the first concrete private house in the Rue Franklin, Paris (1902). Garnier too reacted, both technically and ideologically. He won the Prix de Rome in 1899, and during his stay at the Villa Medici he executed a design for an industrial city in which all the important buildings should be of reinforced concrete.

American artists had broken with traditional styles and methods by building the first skyscrapers at the end of the 19th century. The Chicago school, led by Louis Sullivan, made systematic use of metal frameworks for buildings that were first and foremost functional and designed in an increasingly sober style—a triumph of architectural rationalism. In 1910, Europe discovered the work of Frank Lloyd Wright and was influenced by his Prairie House, a new conception according to which houses were to be incorporated into their natural environment.

These new developments highlight the failure of Art Nouveau. Rejection of the machine and the artificial rehabilitation of craftsmanship were fatal to its development; and when Art Nouveau forms were adopted by industry the result was disastrous. Art Nouveau's fluid, subtle, and often languorous aspect disconcerted the general public and were ill-adapted to mass-production.

After a disappointing reception at the Universal Exhibition of 1900 and resistance from dealers and industrialists who preferred to carry on diffusing *pastiches*, French decorative artists founded the Société des Artistes Décorateurs. Cabinet-makers, potters, glass-makers and iron-workers 'repudiated previous fantasies, strived for the fine working of material, and agreed to look to nature, especially flowers, for a suitable décor for their works' (Koechlin).

The Werkbund exhibition of 1910 exploded like a bombshell in the midst of this timid and confused activity. Decorators now discovered coherent structured interiors with furniture and objects integrated into their architectural environment. The influence of the Werkbund soon influenced even those who consciously rejected it. But the First World War retarded public recognition of the movement, and the Exhibition of Modern Decorative Arts that had been planned for Paris in 1916 was not to be held for another nine years.

THE BALLETS RUSSES

If I had to choose one date for the origin of the style of the 1920s, I should choose 1909, as François Mathey has done. In the preliminary chronology in

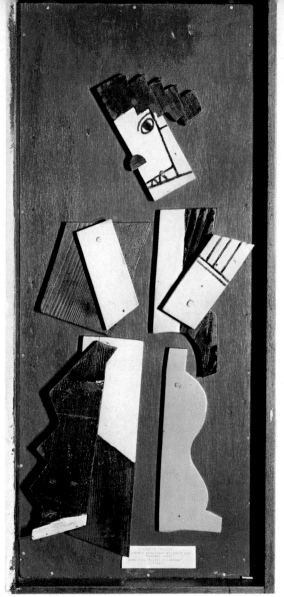

4. Fernand Léger. *Le Charlot cubiste*. 1924.
Wood (73 x 33 cms). Musée Fernand Léger,
Biot.

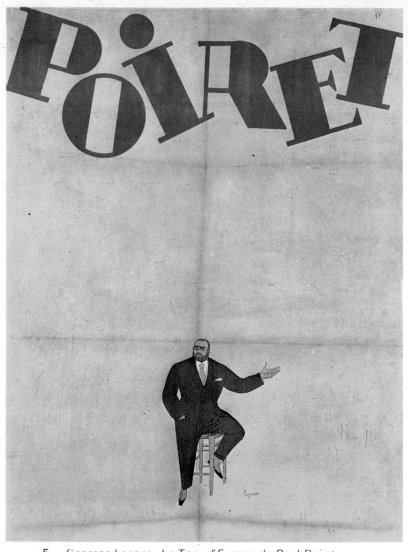

5. Georges Lepape. *Le Tour d'Europe de Paul Poiret*.
1920. Lithograph (74 x 54 cms). The artist's collection.

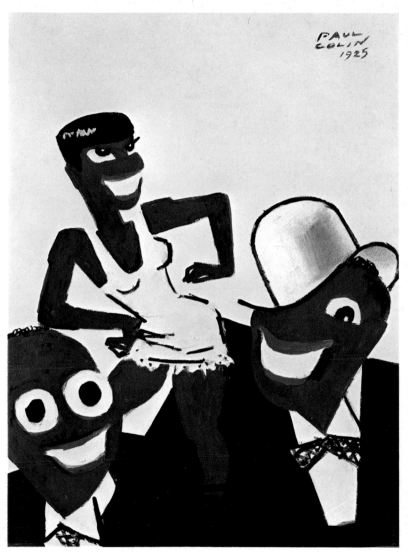

6. Paul Colin. *La Revue Nègre*. 1925. (100 x 74 cms).
The artist's collection.

4. Fernand Léger. *Le Charlot cubiste*. 1924. Wood (73 x 33 cms). Musée Fernand Léger, Biot. © by SPADEM, Paris, 1967. Elements used by the painter for *Le Ballet Mécanique*, a film made while he was collaborating with the Swedish Ballets; in it he tried to harmonise stability and movement.

5. Georges Lepape. *Le Tour d'Europe de Paul Poiret*. 1920. Lithograph (74 x 54 cms). The artist's collection. Lepape and Paul Iribe were the illustrators of Poiret's clothes and career. Lepape remained faithful to Poiret's style all his life.

6. Paul Colin. *La Revue Nègre*. 1925. (100 x 74 cms). The artist's collection. © by ADAGP, Paris, 1967. Sketch for the poster for the Théâtre des Champs-Elysées. This definitely launched Colin; he and Cassandre became the most representative poster designers of the period. The Cubists discovered Negro culture in the early years of the century; in the 1920s everything Negro—jazz, dancing, art, etc.—came into fashion.

7. Robert Mallet-Stevens. Design for a villa. 1923. Pen and ink (48.3 x 63 cms). Musée des Arts Décoratifs, Paris. The influence of Josef Hoffmann, the architect of the Palais Stoclet in Brussels, is apparent in this design; it heralded Mallet-Stevens' future designs, notably the private mansions on the Paris street named after him.

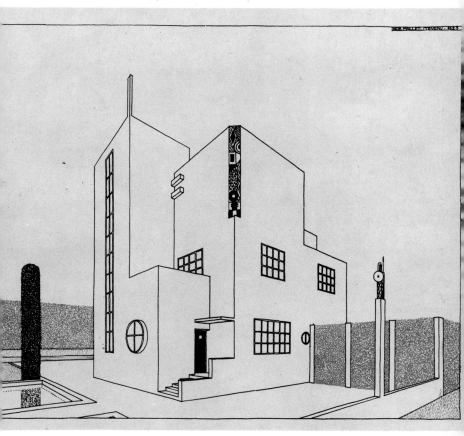

7. Robert Mallet-Stevens. Design for a villa. 1923.

the catalogue of the exhibition at the Musée des Arts Décoratifs, he lists the following events for 1909:

First performance of Serge Diaghilev's Ballets Russes at the Théâtre des Champs Elysées.

First Futurist Manifesto published in Paris.

Picasso: Horta de Ebro landscapes.

Braque: Landscape of La Rocheguyon.

Behrens: AEG Turbine Factory, Berlin.

Blériot's flight across the Channel.

The first performances of the Ballets Russes were received with delirious enthusiasm. They were a completely new kind of spectacle in which dancing, music and painting achieved an unprecedented unity of effect. The painter was the real master of the stage, designing décors, accessories and costumes, as well as being responsible for the programme and poster designs. His role was an essential one, completely integrated into the production. The painters chosen by Diaghilev—Alexandre Benois, Roerich, Korovin, Golovin, Léon Bakst, Larionov and Goncharova—employed unusual, brilliant colours in their stage sets. Jacques-Emile Blanche wrote of the sets for the *Pavillon d'Armide* (1909), 'at last we have colour and tones. Objects are indicated, no longer manufactured at the expense of characters . . .'

When *Shéhérazade* was performed in 1910, the effect was even more striking. Léon Bakst's décor

was 'barbarian', 'reduced to a few lines in which the two dominant and complementary colours, red and green, met with violent impact in a crescendo of glowing splendour'. Bakst's success lay in the fact that he had conceived costumes in terms of the dance; he saw them 'in movement and in the very movement of the poem itself. In this way he succeeded in creating an orchestration of colour which harmonised with the orchestral coloration' (Valdo Barbey).

The success of the Ballets Russes continued unabated until the outbreak of war in 1914, with *The Firebird, The Spectre of the Rose, Petrushka, L'Après-midi d'un Faune* (in which the extraordinary dancer Nijinsky had such a triumph), *The Rite of Spring* and *Le Coq d'Or*. They made an essential contribution to French theatre by revealing the importance of colour and the role of the painter; and the colours of Bakst, Benois and Goncharova were to influence such contemporary decorators as Paul Iribe.

The painter's participation in the theatre was not, of course, an innovation solely attributable to Diaghilev, though no one before him had mastered such an array of talent and originality; the tendency had been growing in Russia, Germany and England since the late 19th century. Jacques Rouché, for example, put into practice the ideas he had picked up during a voyage abroad at the Théâtre des Arts

between 1910 and 1913. Characters and décor were regarded as inseparable, depending on 'a higher factor: the drama for which the décor was to serve as a frame'. In order to achieve perfect unity of effect, Rouché deemed it necessary 'that a painter should become adviser to the producer by designing costumes as well as sets, and by determining the gestures and movements of the actors in agreement with the producer and author'. Painters chosen by Rouché to create the sets for the dramas, comedies and operas presented at the Théâtre des Arts included Drésa, Dethomas, René Piot, Charles Guérin, D'Espagnat, Desvallières, Segonzac, Albert André, Prinet, Robert Bonfils, Laprade and Francis Jourdain.

Rouché's achievement has been obscured by the audacity and brilliance of Diaghilev who from 1917 gave a new impetus to the Ballets Russes by employing French and other Western European musicians and painters. The Russian musicians of the early days, Stravinsky and Prokofiev, were joined by Satie, Auric, Poulenc, Milhaud, and Manuel de Falla; the Russian avant-garde painters, Larionov and Goncharova, were followed by Picasso, Matisse, Braque, Derain, Marie Laurencin, Juan Gris, Max Ernst, Miró, Utrillo and Rouault, and the sculptors Laurens, Gabo and Pevsner. The public discovered Fauvism, Cubism and the other avant-garde move-

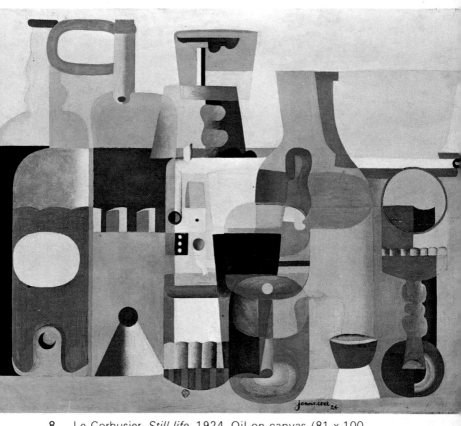

8 Le Corbusier. *Still life*. 1924. Oil on canvas (81 x 100
cms). Le Corbusier Foundation.

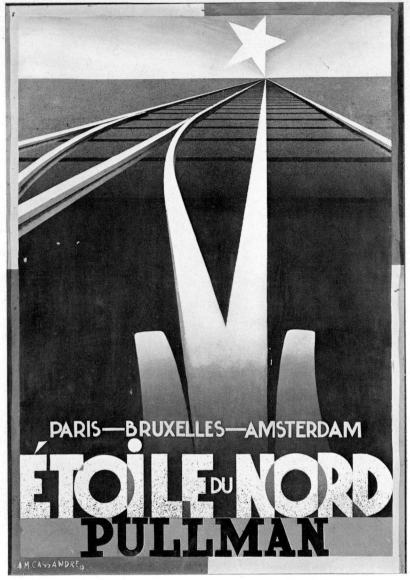

9. A. M. Cassandre. *Etoile du Nord*. 1927. Original design
(116 x 85 cms). Musée National de la Voiture et du
Tourisme, Compiègne.

10. Voisin car. 1926. Association des Amis de l'Histoire de l'Automobile, Paris.

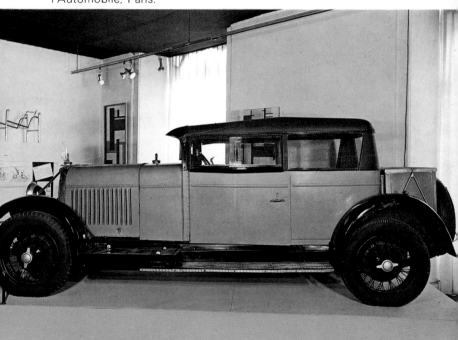

8. Le Corbusier. *Still life*. 1924. Oil on canvas (81 x 100 cms). Le Corbusier Foundation. One of a number of still-life paintings by Le Corbusier between 1920 and 1929. He applied the 'purist' theories of *L'Esprit Nouveau*, which rejected decoration, though not lyricism.

9. A. M. Cassandre. *Etoile du Nord*. 1927. Original design (116 x 85 cms). Musée National de la Voiture et du Tourisme, Compiègne. © by ADAGP, Paris, 1967. With this poster, which permitted him to 'insert the symbols of speed in the rhetoric of imagination' (Delevoye), Cassandre created an advertising style derived from Cubism, in which the lettering played a part of the first importance.

10. Voisin car. 1926. Association des Amis de l'Histoire de l'Automobile, Paris. This 13 horse-power, six-cylinder saloon car belonged to Gabriel Voisin himself. It was a luxury car, designed in a geometrical style taken over from Cubism. For a while its popularity eclipsed that of Renaults and Citroëns.

11. André Mare. Writing pad, *c*. 1925. Incised and painted parchment (31 x 44 cms). Musée des Arts Décoratifs, Paris. In this characteristically *Art Déco* work, the design and colours reveal the influence of Cubism and the Ballets Russes. Mare combined the activities of painter, book-binder and interior decorator.

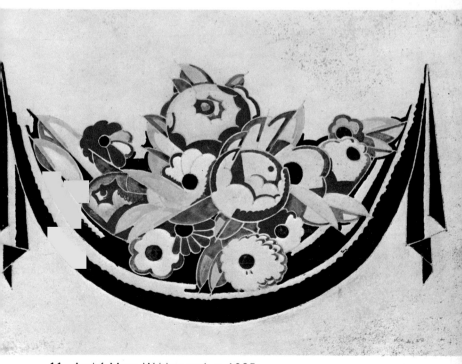

11. André Mare. Writing pad. *c.* 1925

31

ments in the arts through the ballets *Parade* (Cocteau, Satie, Picasso), *The Three-Cornered Hat* (Manuel de Falla, Picasso), *La Boutique Fantasque* (Derain), *Train Bleu* (Cocteau, Milhaud, Laurens, Chanel), *La Chatte* (Pevsner, Gabo), and the rest—in all, forty creations of extraordinary diversity.

A movement had been born that was to be followed on every other French stage with varying success. Painters and decorators like Georges Lepape, André Groult, Fauconnet and Raoul Dufy were invited to take part in theatrical productions. In 1920 Rolf de Maré's Swedish Ballet found a home in the Théâtre des Champs Elysées, where performances were controversial and even scandalous. From a choreographic point of view they were far inferior to the Ballets Russes, but they had the merit of being produced with the aid of important artists— the composers of the group 'The Six', the writers Jean Cocteau and Blaise Cendrars, the painters Jean Hugo, Giorgio de Chirico and Fernand Léger. Between 1920 and 1924 they created some twenty ballets, including *L'Homme et son désir* by Claudel, *Les Mariés de la Tour Eiffel* by Cocteau, Irène Lagut and Jean Hugo, *La Jarre* by Pirandello and de Chirico, *Relâche* by Satie and Picabia, and *La Création du Monde* by Cendrars, Milhaud and Léger. There were many other signs that the arts were becoming inter-

dependent: in 1924, for example, Léger made a film, *Le Ballet Mécanique*; and in the same year the film director Marcel l'Herbier asked Mallet-Stevens to make the sets for *L'Inhumaine*.

FUTURISM, FAUVISM, CUBISM

In 1909 Parisians became aware of Futurism as well as the Russian Ballet. On February 20th a manifesto of Futurist poetry was published in *Le Figaro* by the Italian poet Filippo Tommaso Marinetti. The violently polemical text announced the arrival of a poetry in harmony with 'the great masses moved by work, pleasure or revolt', and with the era of the machine and speed. 'Speed is our god, the new canon of beauty: a racing car is more beautiful than the Victory of Samothrace.' In the following year the *Manifesto of Futurist Painters* was published, signed by Carlo Carrà, Boccioni, Russolo, Giacomo Balla and Gino Severini. Basing itself on the scientific spirit of Neo-Impressionism, Futurist painting aimed to express speed, energy and power in plastic terms. In 1914 Futurist influence on Italian architecture became apparent with the exhibition of Antonio Sant' Elia's project for a 'New City' and similar designs by Mario Chiattone.

Futurism was only one aspect of the artistic ferment in the years before World War I. From the beginning of the century, the Fauve artists Matisse, Derain, Vlaminck, Marquet, Dufy and Braque had been at work in France, producing paintings characterised by the use of pure colour and two-dimensional representation, modelling and chiaroscuro.

In 1907 Picasso's *Demoiselles d'Avignon* effectively began the Cubist revolution. A favourable climate had been created by the discovery of Negro art, and the retrospective exhibitions of Seurat (1905) and Cézanne (1907). Picasso and Braque had broken with Fauvism and were trying to represent coloured volumes on flat planes without perspective or light; the objects chosen were usually very simple, and were defined in terms of their geometrical forms. The Cubists rejected decoration; their conception of art was consciously analytical, realistic and objective. Cubism falls into three main periods: a phase in which the influence of Cézanne's theories predominated (1907–1909); the 'analytical' phase (1910–1912); and the 'synthetic' phase. This was defined by Juan Gris ('out of a cylinder I make a bottle'), and was a prelude to the experiments soon to be made with abstract forms.

Futurism, Fauvism and Cubism all had some influence on the decorative art of the 1920s. The

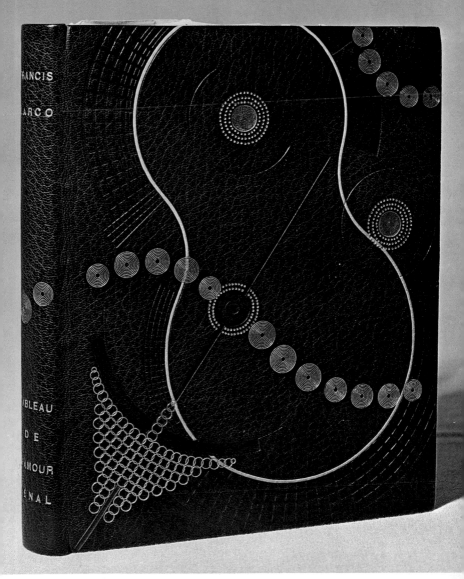

12. Pierre Legrain. Book-binding for Francis Carco's
Tableau de l'amour venal. 1928. Black morocco leather
decorated with a mosaic. Pierre Bérès Collection, Paris.

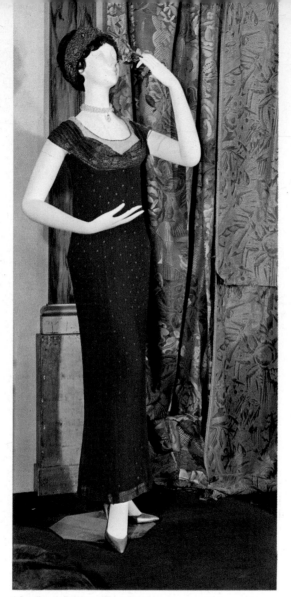

13. Paul Poiret. 'Eugénie': satin and organdie
dress. 1907 Centre de Documentation du
Costume, Paris.

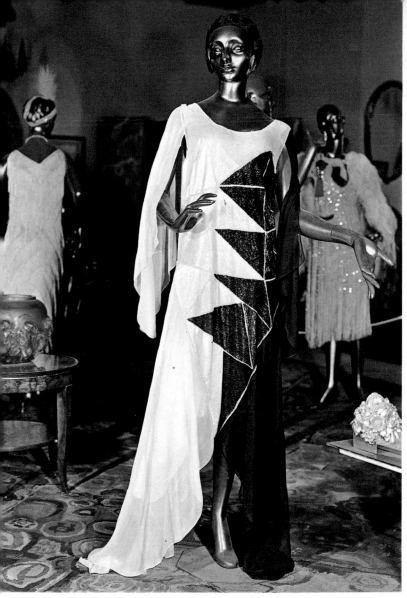

14. Jeanne Lanvin. Evening dress. 1927.

12. Pierre Legrain. Book-binding for Francis Carco's *Tableau de l'amour venal*. 1928. Black morocco leather decorated with a mosaic. Pierre Bérès Collection, Paris. © by ADAGP, Paris, 1967. Legrain's original style, which became widely influential, is well illustrated by this binding. Based on geometrical forms, it expresses the spirit of the book (illustrated by Luc-Albert Moreau) and effectively invites the reader to open it.

13. Paul Poiret. 'Eugénie': satin and organdie dress. 1907. Centre de Documentation du Costume, Paris. The dress was reproduced in Paul Iribe's album, *The Clothes of Paul Poiret*, published in 1908. It is an evening dress, inspired by the Directoire style. With this collection Poiret began the revolt against restrictive clothes for women. In the background, brocades designed by Raoul Dufy, Süe and Mare, and Charles Martin.

14. Jeanne Lanvin. Evening dress. 1927. Pearled and embroidered *crêpe georgette*. Centre de Documentation du Costume, Paris. The geometricising tendency of the period is evident in the asymmetrical design of this handkerchief dress by Lanvin. The carpet was designed by Bénédictus for the 1925 Exhibition.

15. Sonia Delaunay. Embroidered jacket of wool and silk. 1924. Centre de Documentation du Costume, Paris. © by ADAGP, Paris, 1967. This jacket, with its embroidered geometrical patterns, represented the direct application of Robert and Sonia Delaunay's 'simultaneist' painting theory to fashion designs, and revolutionised the art of weaving.

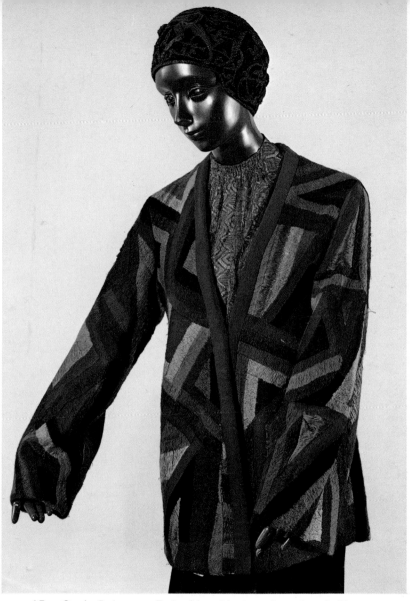

15. Sonia Delaunay. Embroidered jacket of wool and silk 1924. Centre de Documentation du Costume, Paris.

nihilistic revolt of Dada—plastically expressed by *collages* (derived from Cubism) and 'free forms' created by chance or the subconscious—had a more limited influence, despite the adhesion of such major artists as Arp, Picabia, Marcel Duchamp and Ernst. The same is true of Dada's successor, Surrealism, which organised and experimented with the data of the subconscious and endeavoured to discover new relationships between objects. The wider importance of these movements became apparent only very much later.

EXPRESSIONISM

Expressionism, a recurring feature of Nordic and Slav art, flourished in Germany and Scandinavia in particular. There were two major groups before the Great War: Die Brücke, the most important members being Kirchner, Nolde, Schmitt-Rottluf, Pechstein, Heckel and Mueller; and Die Blaue Reiter, founded in Munich on the eve of the War. The chief members, Kandinsky, Marc and Macke, held a series of spectacular exhibitions to which many avant-garde European artists contributed: Henri Rousseau, Braque, Derain, Picasso, Vlaminck, La Fresnaye, Goncharova, Larionov, Malevich, Klee and Delaunay.

The Blaue Reiter took a stand against academicism, Kandinsky proclaiming the group's faith in 'inner necessity': 'We are not trying to propagate any precise or particular form. Our aim is to show how the drives of artists may be fulfilled in many different ways.' Klee and Kandinsky later met again at the Bauhaus, first at Weimar and then at Dessau.

NEO-PLASTICISM

One of the most important artists at work in Europe before 1914 was the Dutch painter Piet Mondrian. His work was to have a decisive influence on the art of the 1920s, particularly architecture and the decorative arts. He had been influenced by Cubism, which he had encountered in Paris in 1911, and by means of a progressive process of abstraction he had gradually evolved a style in which 'everything became rhythm, orchestration of lines and colours free from any suggestion of objective reality' (Michel Seuphor). Mondrian's doctrine was that of a pure plastic art based on the exclusive use of right-angles in horizontal-vertical positions, and of the three primary colours and the three 'non-colours', white, black and grey. 'Neo-Plasticism' was defended by the review *De Stijl*, founded in 1917 by Théo van

Doesburg, which brought together Oud, Van-
tongerloo and Rietveld.

ARCHITECTURE:
THE INTERNATIONAL STYLE

In 1909 Peter Behrens completed the great AEG
turbine factory in Berlin. This rounded off two years'
work in which the architect had tackled a whole
complex of problems connected with the factory:
Behrens had been called upon to design electric
equipment, all the publicity material from wrappings
to letter heads, and both the commercial and industrial
premises. He later built more factories for the AEG.

This participation by an artist in the work of a
great industrial firm is of capital importance in the
history of 20th-century art. In 1898 Van de Velde
had designed posters, wrappers and publicity signs
for a firm manufacturing food products; but his
example had not been widely followed. Behrens's
work was a highly successful application of the
programme of the Deutscher Werkbund; it an-
nounced the intervention of art in the sphere of
industry, and the entry into everyday life of beautiful
and functional machine-made objects. It thus fore-
shadows modern industrial design.

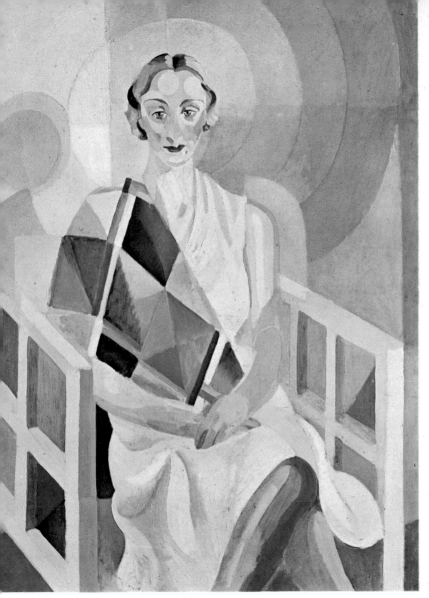

16. Robert Delaunay. *Portrait of Mme Heim* (study).
1926–1927. Oil on canvas (130 x 97 cms). Sonia Delaunay
Collection, Paris.

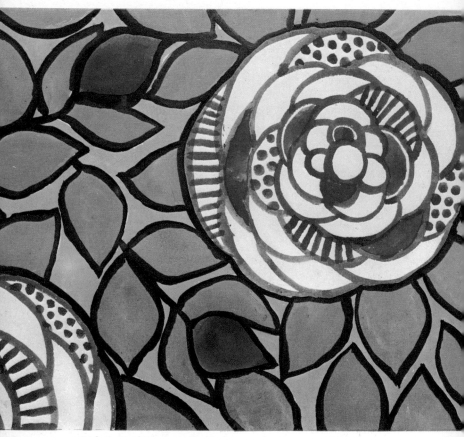

17. Atelier Martine. Design for textile. 1911–1912. Water-
colour. Poiret-de Wilde Collection, Paris.

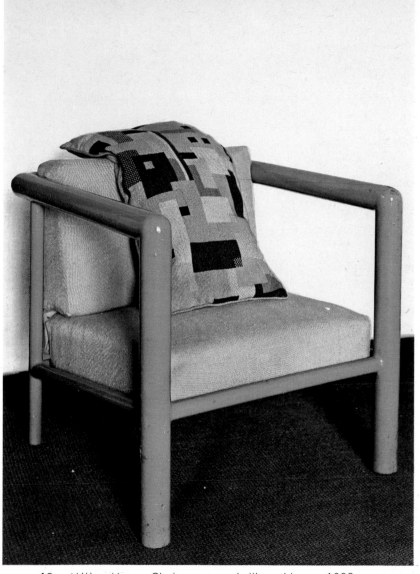

18.　Hélène Henry. Chair-cover and silk cushion, *c.* 1928.
Chair by Mallet-Stevens. Mallet-Stevens Collection, Paris.

16. Robert Delaunay. *Portrait of Mme Heim* (study). 1926–1927. Oil on canvas (130 x 97 cms). Sonia Delaunay Collection, Paris. © by ADAGP, Paris, 1967. In this painting, the wife of the fashion designer Jacques Heim is wearing a 'simultaneist' dress and scarf by Sonia Delaunay, who designed for fashion houses.

17. Atelier Martine. Design for textile. 1911–1912. Watercolour. Poiret-de Wilde Collection, Paris. By a pupil of the Atelier Martine, founded in 1911 by Poiret. The bold colours and stylised rose and leaf motifs owe a good deal to the Ballets Russes.

18. Hélène Henry. Chair-cover and silk cushion, *c*. 1928. Mallet-Stevens Collection, Paris. Mallet-Stevens' chair, made of green lacquered steel tubing, was upholstered with a hand-woven cover by Hélène Henry, the creator of a style which depended on material and weaving for effect. The patterns on the cushion were inspired by Léger's murals of the 1924–1926 period.

19. Fernand Léger. *La Création du Monde*. 1924. Wool (283 x 395 cms). Musée Fernand Léger, Biot. © by SPADEM, Paris, 1967. The tapestry was woven after a design for the curtain of *La Création du Monde*, a ballet by Rolf de Maré for which Léger designed the scenery and costumes (1922).

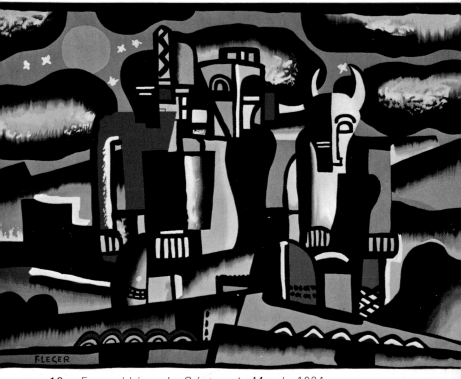

19. Fernand Léger. *La Création du Monde*, 1924.

Behrens and two other German architects, Walter Gropius and Bruno Taut, are the outstanding figures of the generation that invented modern architecture. In the 'twenties, two concepts underlaid and determined experiments: the unity of the arts and functionalism. The new architecture proposed to be '. . . timeless, deriving its laws from the encounter between purpose and material'. Wolfgang Pehnt goes on to say, in his introduction to the *Encyclopaedia of Modern Architecture,* 'That is why the functionalist argument carried such weight. It seemed to guarantee that architecture would now evolve according to rules that would be constant because they depended on the nature of man or the intrinsic character of materials.'

The word 'international', first applied to architecture of the period by Gropius in 1924, described buildings with common features in Germany, Switzerland, the Netherlands, Russia and the United States. It found expression not only in works by individuals, but also in such achievements as the Weissenhof estate at Stuttgart (1927), which was the result of teamwork. After the decline of Cubism, the new architecture maintained a close relationship with the movements which had sprung from Cubism: Mondrian's Neo-Plasticism, Constructivism and Suprematism. It gave a spatial interpretation to

the discoveries based on the three principles defined in 1932 by the American architects H. R. Hitchcock and Philip Johnson: priority of volume; abandonment of axial symmetry in favour of 'an organisational concept' which made possible a new distribution of the architectural elements; and condemnation of all arbitrary decoration. The same desire for freedom to give form and style to new materials can be detected in Rietveld's Schroeder House (1924), Gropius' Bauhaus at Dessau (1925–1926), Neutra's Lovell Health House at Los Angeles (1927–1929), Le Corbusier's Villa Savoye at Poissy (1929), Mies van der Rohe's German pavilion at the Barcelona Exhibition (1929) and Aalto's Paimio Sanatorium (1929–1933).

ARCHITECTURE IN FRANCE

Modernistic elements appeared in French architecture as early as the beginning of the century, in the work of Tony Garnier and Auguste Perret. In the 1920s it was dominated by the attitudes expressed in *L'Esprit Nouveau,* a review founded in 1920 by Ozenfant and Le Corbusier. Le Corbusier had been in contact since 1907 with such innovating architects as Josef Hoffmann, Garnier, Perret and Behrens, and

with the Deutscher Werkbund; and he had absorbed the discoveries of Cubism. From the very beginning of his career he rejected the use of any elements reminiscent of past styles. He adopted simple geometrical forms to create a new distribution of interior space, and tackled the problem of the modern metropolis in such works as the Maison Domino (1915), the *maquette* for the Second Citrohan House (1922), the Maison Ozenfant (1922), the garden-city of Bordeaux-Pessac (1925), the Pavillon de l'Esprit Nouveau at the 1925 Exhibition, the Maison Cook at Boulogne-sur-Seine (1925), and two houses in the Weissenhof estate (1927).

Several other French architects refused to conform to the traditional style; their work is known to us through the all-too-few private buildings they were commissioned to design. Robert Mallet-Stevens and Pierre Chareau are particularly outstanding by virtue of their originality and their awareness of the problems of structure and content.

After being influenced by Hoffmann and the Viennese school, Mallet-Stevens built villas (Villa Noailles, Hyères, 1923), shops (Bailly, Boulevard de la Madeleine, Paris), office blocks (Alfa-Romeo, Rue Marbeuf, Paris, 1925) and, most important, a series of private houses at Auteuil (1925–1927) on the street that has been named after him. For the 1925

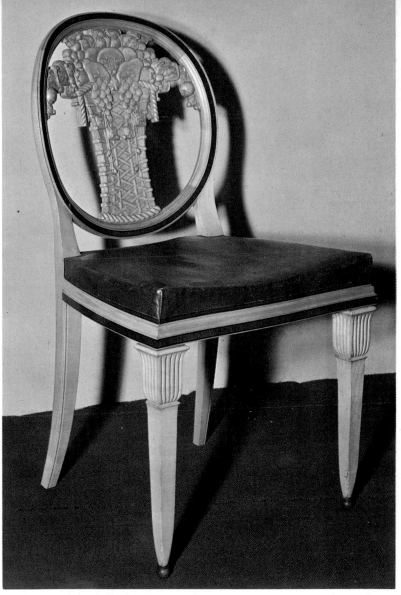

20 Paul Follot. Chair. *c*. 1913. Carved sycamore, ebony and amaranthe (91 x 58.5 x 43.5 cms). Musée des Arts Décoratifs, Paris.

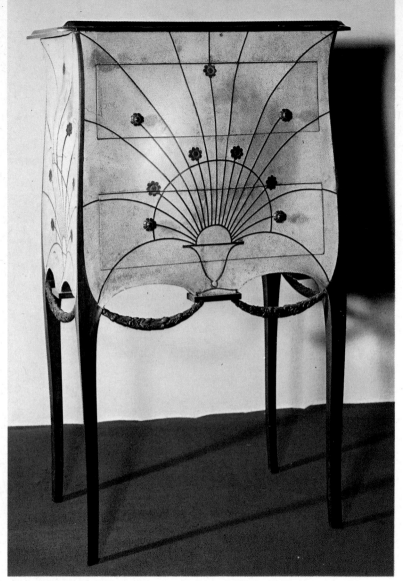

21. Paul Iribe. Small commode. *c.* 1912. Mahogany,
sharkskin, inlaid and carved ebony (91 x 49 x 32 cms).
Musée des Arts Décoratifs, Paris.

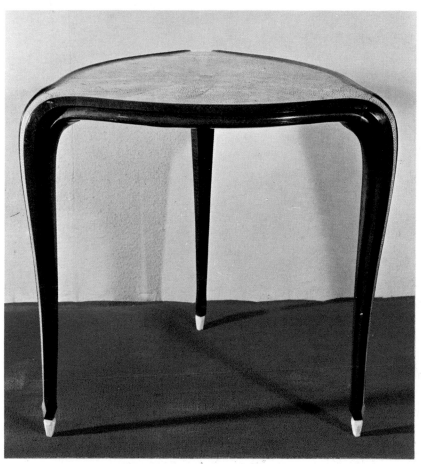

22. Clément Rousseau. Three-legged table, c. 1921.
Rosewood and sharkskin. Musée des Arts Décoratifs, Paris.

20. Paul Follot. Chair, *c*. 1913. Carved sycamore, ebony and amaranthe (91 x 58.5 x 43.5 cms). Musée des Arts Décoratifs, Paris. A striking example of Follot's taste for fine materials, rich decoration, and 'luxury' rather than 'mass-produced' effects. The fruit basket carved on the back of the chair by his collaborator Laurent Malclès was one of Follot's favourite subjects.

21. Paul Iribe. Small commode, *c*. 1912. Mahogany, shark-skin, inlaid and carved ebony (91 x 49 x 32 cms). Musée des Arts Décoratifs, Paris. Part of the furniture by Iribe that Doucet commissioned for his apartment in the Avenue du Bois after the sensational sale of his 18th-century collection in 1912.

22. Clément Rousseau. Three-legged table, *c*. 1921. Rose-wood and sharkskin. Musée des Arts Décoratifs, Paris. Clément Rousseau, a sculptor who rarely made furniture, provided the Baron de Rothschild with a complete set of furniture. It was made from rare woods and pale sharkskin, in a style that displayed strong traditional characteristics.

23. Clément Mère. Small commode, *c*. 1921. Rosewood and stamped leather. Musée des Arts Décoratifs, Paris. Mère began to make furniture in 1910, employing materials and techniques he had previously used for snuff boxes and other fashionable objects: lacquers, stamped and patinated leather, and inlaid ivory.

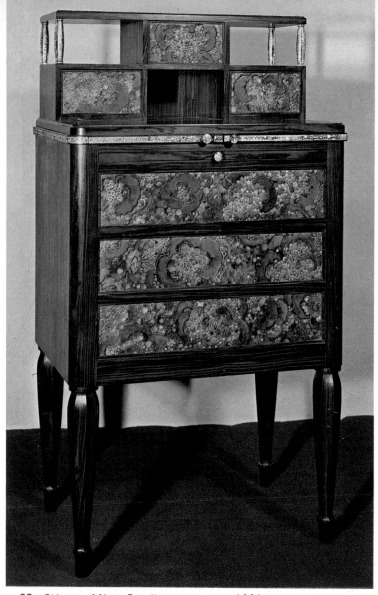

23 Clément Mère. Small commode, c. 1921.

Exhibition he and the sculptors Jan and Joël Martel, were commissioned to create the Pavilion of Tourism. His architecture was Cubist, at once lucid and complex in style, with different, contrasting volumes combined, façades enlivened by detached areas and reliefs, and interiors ordered in free volumes.

Pierre Chareau was a friend of the Cubists and Surrealists, and a collector of their works. In 1927 he built the clubhouse of the golf club of Beauvallon; in 1928–1931 his masterpiece, the famous 'glass house' of Dr and Mme Jean Dalsace, Rue St Guillaume, Paris, in collaboration with Bijvoët. This iron and glass house was revolutionary in conception and aesthetic effect, with its façade of concave round glass plaques which allowed the rooms in the interior to be lit by projectors placed outside, its three unevenly superimposed levels, and its sliding and revolving doors also useable as cupboards.

From 1920 there were exchanges between France and centres in the rest of Europe by means of exhibitions (the 1925 Exhibition and the Werkbund Exhibition in the 1930 Salon des Artistes Décorateurs); works in France by foreign architects (Loos, Van Doesburg); French architects working abroad; and such specialised reviews as *Cahiers de l'Effort Moderne* by Léonce Rosenberg (1925–1927) and, from 1923, the series *L'Architecture Vivante*.

MACHINERY AND SPEED

The first flight across the English Channel, by Blériot, also occurred in the important year 1909. This exploit symbolised two events that were to transform radically the post-war years: the intrusion of the machine into every area of life, and the discovery of speed.

More than anyone else in France, Le Corbusier was the defender of the machine. 'That modern phenomenon, the machine, is producing a spiritual reformation in the world. . . . The lesson of the machine lies in the pure relationship between cause and effect it contains. Purity, economy, tension, towards wisdom. A new desire: an aesthetic of purity, of exact relationships between interdependent parts. . . . The great life of the machine has profoundly shaken society, has snapped all chains, opened all doors, and cast its eyes in every direction. . .'

The lesson of the machine was understood by the men who formed the Deutscher Werkbund and founded the Bauhaus (1919). In France, it was deliberately ignored, even rejected, by the majority. Speed was a novelty. The 1920s were intoxicated by it, but had no presentiment of the way in which it was to revolutionise life. The aeroplane and the automobile were designed in new forms taken over from

Cubism and its successors. A whole new aesthetic was created around them; Le Corbusier designed an automobile of maximum economy, foreshadowing the Citroën 2 CV, Ruhlmann worked out designs for the lines of cars, and the brothers Martel made models for radiator caps.

The effects of speed were felt by an entire epoch; it imposed its rapidly changing, uncertain tempo on the times. The public felt its effects most in the cinema, with its syncopated rhythms, and learned to adapt its perception to a rapid, abrupt succession of images, to variations of scale and unexpected relationships.

'The speed factor is now decisive', wrote Guillaume Janneau in 1925. 'It is to conjure away its effects that interior decoration and the arts intended for private contemplation have become calm and sober. It is to obey its laws that the arts of the street— posters and monuments, window displays and shops —have become simpler, barer, seeking for easily legible forms and ways of instantly capturing the eye of the passer-by.'

THE DECORATIVE ARTS IN FRANCE

French decorative artists, who had formed themselves into a society in 1901, were determined to

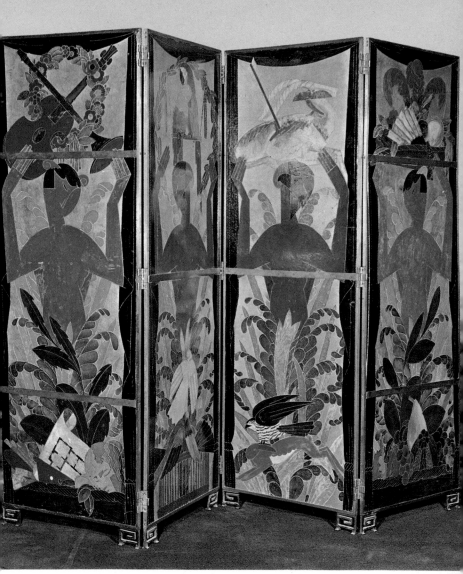

24. André Mare. Screen. 1922. Lacquer over parchment and bronze. Michel Mare Collection, Paris.

24. André Mare. Screen. 1922. Lacquer over parchment and bronze. Michel Mare Collection, Paris. Mare was both a painter and a decorator, reconciling his geometricising pictorial tendencies with the decorative requirements of the object. The result is a combination of decorative motifs, brilliant colours and precious materials.

25. André Groult. Chest of drawers. 1925. Sharkskin and ivory. N. Manoukian Collection, Paris. This was part of the furniture for the Chambre de Madame in the pavilion of the French Embassy, presented by the Société des Artistes Décorateurs at the 1925 Exhibition. It shows the boldness and originality with which Groult worked without breaking completely with tradition.

26. Compagnie des Arts Français. Mahogany armchair; round table with a single ebony support; faience pipe-vase. 1925. Private collection. A typical set of furniture by Süe and Mare, the leading spirits in the Compagnie des Arts Français, whose principles were sobriety, logic and tradition. The screen is by André Marty.

27. Emile-Jacques Ruhlmann. Chest of drawers. 1924. Macassar ebony veneer and ivory. Lamy-Lassalle Collection, Paris. Presented in the Collector's House in the 1925 Exhibition. A perfect example of Ruhlmann's art, in which a fine cabinet-making technique served to produce simple, discreet forms. Note the famous spindle legs.

25. André Groult. Chest of drawers. 1925.

26. Compagnie des Arts Français. Mahogany armchair; round table with a single ebony support faience pipe-vase. 1925. Private collection.

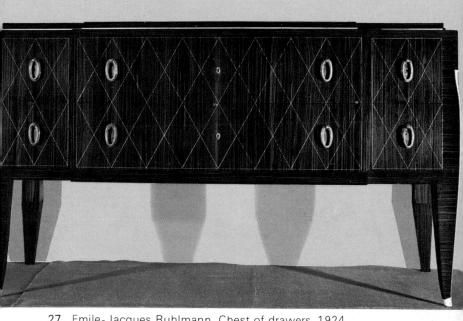

27. Emile-Jacques Ruhlmann. Chest of drawers. 1924. Macassar ebony veneer and ivory. Lamy-Lassalle Collection, Paris.

make up for their failure at the 1900 Exhibition and break down the indifference of the public. They took part in exhibitions as often as possible: in France, at the annual salons organised at the Pavillon de Marsan from 1907, at the Salon d'Automne in the Grand Palais, in the salons of the Artistes Français and the Société Nationale (which opened sections devoted to decorative art), in the exhibitions of applied art organised by the City of Paris in the Musée Galliera; and abroad, at all the international exhibitions. Realising that they could not count on support from industry, they presented themselves directly to the public, hoping that numerous exhibitions would effect a change in taste.

It is tempting to judge this period of search and confusion by its results or repercussions, or by comparison with the bold and original figures about to revolutionise the arts. But the only valid approach is to examine the period without hindsight, as it appeared to contemporaries. Before 1910, the password was 'cheapness', and some decorative artists (notably Gallerey and Dufrène) resorted to machine production in order to sell their works at low prices. Ornament was sometimes banished: Francis Jourdain even went so far as to suppress the mouldings on his furniture in order to concentrate on relationships between masses. The reception of this work con-

tinued to be unfavourable. 'In the 1906 Salon of Decorative Artists', wrote Moussinac, 'every form and nuance is employed, but there is a complete absence of boldness and force.' In this transitional and unrewarding period, different professions and theories clashed violently. Carpenter and architect were already at odds over Lucet's 'American combined': sofas which were combined with a bookcase or cupboard, and could be transformed into beds. Cheap furniture was a definite failure: the public considered some of it 'kitchen furniture' and the rest too expensive. In 1908 the 3rd Salon of the furniture industry opened a new competition for cheap furniture by presenting a bedroom in Louis XVI style—a complete retreat.

We are no longer disposed to condemn the public or the critics who inflicted this setback. There is not much that can be defended in the furniture, other objects and decoration produced between 1900 and 1910. None of the decorative artists who exhibited in the various salons of the time had enough personality to be able to impose new directions or new formulas. The only artist who might have done so was Francis Jourdain, a painter who had been attracted by the idea of really original furniture with purity of mass, linear simplicity, fine wood, and perfect adaptation of design to function.

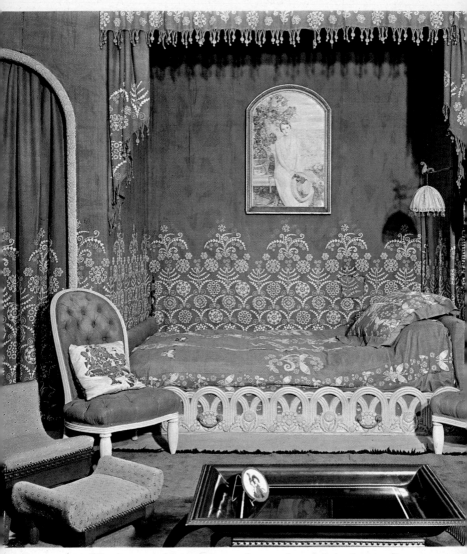

28. Armand-Albert Rateau. Jeanne Lanvin's bedroom, Rue
Barbet-de-Jouy. 1920–1922. Musée des Arts Décoratifs,
Paris.

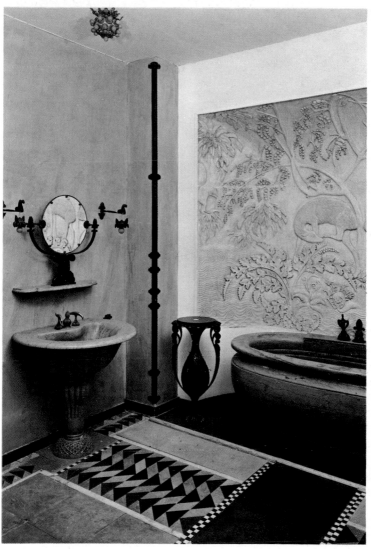

29 Armand-Albert Rateau. Jeanne Lanvin's bathroom, Rue
Barbet-de-Jouy. 1920–1922. Musée des Arts Décoratifs,
Paris.

28. Armand-Albert Rateau. Jeanne Lanvin's bedroom, Rue Barbet-de-Jouy. 1920–1922. Musée des Arts Décoratifs, Paris. The walls are covered with 'Lanvin blue' silk embroidered with yellow and white patterns of roses, palms and daisies. The bed and chairs are in painted wood and varnished wild cherry-wood, the lampholder and fittings in bronze with a green patina.

29. Armand-Albert Rateau. Jeanne Lanvin's bathroom, Rue Barbet-de-Jouy, 1920–1922. Musée des Arts Décoratifs, Paris. The bath and washbasin are in Sienese yellow marble. The fittings and mirror, in bronze with a green patina, are decorated with butterflies, acanthus leaves, palms and pheasants, as are the taps. In the alcove there is a stucco bas-relief.

30. Marcel Coard. Armchair, c. 1920–1925. White lead and lacquer veneers (86 x 66 x 78.5 cms). Musée des Arts Décoratifs, Paris. This armchair, covered with lozenge-patterned horsehair upholstery, is from the collection of Jacques Doucet. Coard's training as an architect greatly influenced his work.

31. Pierre Legrain. Chair, c. 1925. Palm-wood veneer and lacquer (78 x 45 x 45 cms). Musée des Arts Décoratifs, Paris. From the Studio at Neuilly, which Legrain, Coard and Mergier furnished for Jacques Doucet. The shapes are rigid and stressed, in harmony with the hard parchment of the seat cover.

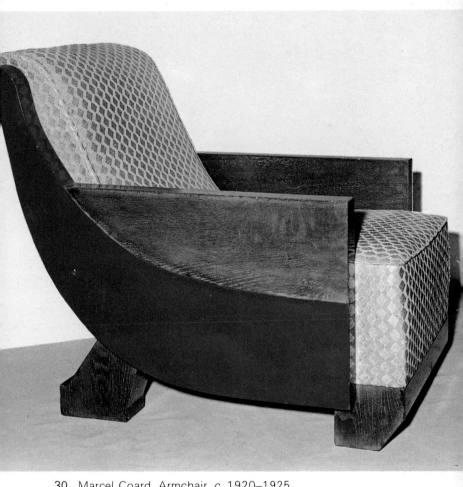

30. Marcel Coard. Armchair, *c.* 1920–1925.

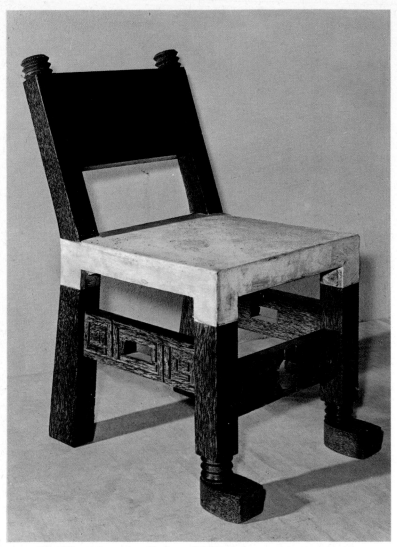

31. Pierre Legrain. Chair, *c*. 1925. Palm-wood veneer and lacquer (78 x 45 x 45 cms). Musée des Arts Décoratifs, Paris.

1909 was of course the decisive year. The Ballets Russes liberated colour, which invaded interiors, furniture, textiles, objects of all kinds. Paul Poiret founded the Atelier Martine. The *ensemblier* took over from the decorator. 'An *ensemble* is a combination of decorative elements which may be of no individual importance, and which have no other purpose than to contribute towards an overall effect. An *ensemble* is a setting and nothing but a setting.' (Janneau) Thus began the era of painted and varnished wood, lacquers and veneers, bright blue and red, and sombre violet, black and silver. In 1925 Janneau felt justified in writing, 'The school of 1910 understood that new forms are not born out of the imagination of artists but out of real needs; it is not in an ivory tower that a chair must be designed, but in the apartment in which it is to be useful.'

All the same, such achievements remained isolated despite the Werkbund display (an 'admirable example of organisation and unity') in the Autumn Salon of 1910. This was clearly apparent in the French section of the Turin Exhibition (1911). Confronted by the work of Behrens, Olbrich, Bruno Paul, Mackintosh and Herbert MacNair, France put forward a collector's study designed by Jallot, Eugène Gaillard, Süe and Huillard, Paul Follot and Maurice Dufrène— a heterogeneous group of artists with nothing in

common. The Werkbund exhibition seemed to have aroused the nationalism of the decorative artists. The precise designs for a German interior incited French artists and craftsmen to stress the French character of their work, with the result that they either regressed to the styles of the 18th century or concentrated on fashionably luxurious work. Such uncertainties gave comfort to all who disliked modern art, including dealers and manufacturers who wanted to go on selling furniture in well-tried 'styles' which they knew were assured of a market, and architects who opposed the introduction of modern objects into their *pastiche*-houses.

On the eve of the War, one young school did succeed in forming a style with roots in French provincial life and in 'the last traditional style we have'—that of Louis-Philippe—'while it would be completely arbitrary', as one of the school, André Véra, wrote, 'and certainly illogical to take inspiration from such or such an earlier style, as some have recommended'. These young artists were grouped around André Mare, and condemned the individualism of the early years of the century. They were the precursors of the Compagnie des Arts Français of 1919. They chose '. . . the basket and the garland of flowers and fruits . . .' as the symbol of the new style, striving for 'qualities of clarity, order and harmony. . . .

The style of our time will form itself unconsciously and in anonymity.'

A genuine concern with the development of decoration led department stores to organise competitions. The government also began to take an interest: it was planned to hold an 'International Exhibition of Modern Decorative and Industrial Arts' in Paris in 1916. Subsequent events made it necessary to postpone the project, which was scheduled for 1921, then for 1922, and finally held in 1925.

The War, which affected German art so profoundly, had little effect on those members of the young school who believed they had reconciled tradition with modernism. The tendency to abandon individual for collective effort grew stronger. Following Süe's and Mare's foundation of the Compagnie des Arts Français, other workshops were formed, often within the department stores: the 'Primavera' with M. and Mme Gauchet-Guillard at the Printemps, 'La Maîtrise' with Maurice Dufrène at the Galeries Lafayette, the 'Pomone' with Paul Follot at the Bon Marché, and the 'Studium' with Kohlmann and Matet at the Louvre. They had all assimilated Cubism and proclaimed their attachment to the principles of order, equilibrium, discipline, logic and function—in verbal terms the same principles

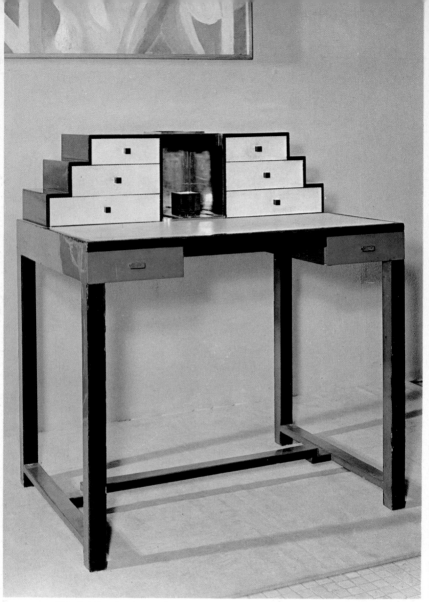

32. Lady's writing desk, *c*. 1920–1925. Lacquered wood,
parchment and metal (91.5 x 81 x 59 cms). Musée des
Arts Décoratifs, Paris.

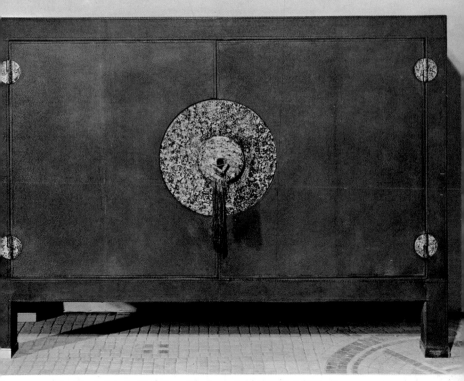

33. Paul-Louis Mergier. Cupboard, *c.* 1928–1929. Green
morocco leather, ivory, parchment and lacquer (103 x 130 x
39 cms). Musée des Arts Décoratifs, Paris.

32. Lady's writing desk, *c*. 1920–1925. Lacquered wood, parchment and metal (91.5 x 81 x 59 cms). Musée des Arts Décoratifs, Paris. The pieces of furniture chosen by Jacques Doucet reflect his taste for Cubist painting and sculpture; this painted writing desk may have come from the Atelier Martine.

33. Paul-Louis Mergier. Cupboard, *c*. 1928–1929. Green morocco leather, ivory, parchment and lacquer (103 x 130 x 39 cms). Musée des Arts Décoratifs, Paris. Jacques Doucet was impressed by a leather-covered chest of drawers by Mergier, and commissioned him to make a piece of furniture to hold manuscripts. The lock and hinges are decorated with lacquer medallions inlaid with mother-of-pearl and eggshell, and the interior is lined with parchment.

34. Francis Jourdain. Chair with wickerwork seat and back. 1925. M. David Collection, Paris. Francis Jourdain aimed to produce low-priced furniture for a wide public; this is an interesting example of his work.

35. Pierre Chareau. Bookshelves and writing desk. 1925. Palm-wood, rosewood veneer, lacquered beech. Private collection and Musée des Arts Décoratifs, Paris. This *ensemble* was created for the pavilion of the French Embassy at the 1925 Exhibition. It was a fresh and original contribution to furniture design—the contribution of a designer with a large conception of interior furnishing adapted to a precise function.

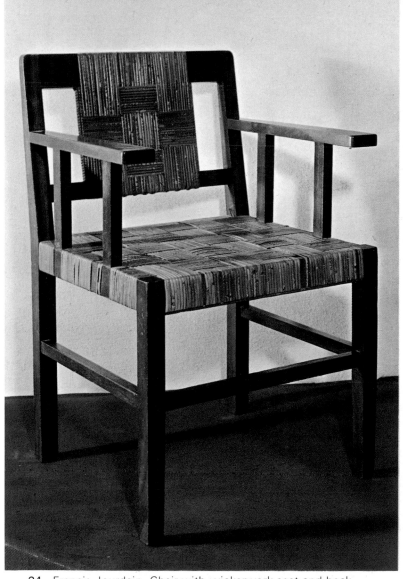

34. Francis Jourdain. Chair with wickerwork seat and back.
1925.

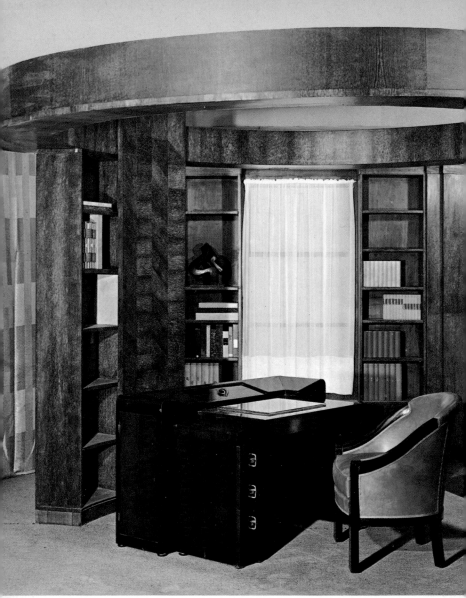

35. Pierre Chareau. Bookshelves and writing desk. 1925.
Palm-wood, rosewood veneer, lacquered beech. Private
collection and Musée des Arts Décoratifs, Paris.

as those held by Mallet-Stevens, Pierre Chareau, René Herbst, Francis Jourdain and other artists with whom they disagreed violently.

Mallet-Stevens and the others were already concerned with organising space in apartments in which studios and the living-rooms for multiple uses were becoming increasingly common; and kitchen and bathroom were receiving their attention. Whereas the workshops mentioned in the previous paragraph won the confidence of the public with enthusiastic designs conforming to the style of contemporary life without breaking completely with tradition, the uncompromising 'moderns' met with indifference and even hostility. This was especially the case with the L'Esprit Nouveau group (Le Corbusier, Pierre Jeanneret and Charlotte Perriand), whose programme and achievements aroused distrust. It was 'an instinctive distrust, a defensive reaction against everything new, justified with regard to Dada and Surrealism, which questioned the whole of society and even denied it, but pointless when directed at those who proposed to give order and reason back to it. Possibly fear led them to confuse constructors and destroyers; the naked walls and right-angles of the one group seemed as scandalous as the verbal excesses of the other. More than anything else, however, it was the intoxication of the post-war

period, the illusion of power regained, and the enthusiastic feeling that life had become easy again—as it was before—that prevented people from grasping the real situation' (François Mathey).

'If the house is white all over,' wrote Le Corbusier, 'the shapes of things stand out without any possible ambiguity; the volume of things will appear clear-cut; the colour of things is categorical. The white of whitewash is absolute. Everything stands out against it and is displayed absolutely: black against white, frank and truthful. Put in objects that are unsuitable or in bad taste, and you can't miss them. You might call it the X-ray of beauty, a permanent court of judgement, the eye of truth.' The use of whitewash was contrary to the whole spirit of traditional interior decoration, for it suppressed hangings and wallpapers, introduced new light and dimensions, and required different furniture. 'There are, perhaps, people who think against a black background. But the work of this epoch—so bold, so perilous, so bellicose, so conquering—seems to expect of us that we should think against a white background.'

The creation of new forms, the use of new materials, the search for beauty in utility, were the principles which made René Herbst, who founded the Union des Artistes Modernes in 1930, the leader of all those who elected to engage art in modern life

36. Robert Mallet-Stevens. Office furniture, c. 1928.
Chrome-plated and painted metal tubing. Musée des Arts
Décoratifs, Paris.

36. Robert Mallet-Stevens. Office furniture, c. 1928. Chrome-plated and painted metal tubing. Musée des Arts Décoratifs. Paris. The furniture of Mallet-Stevens' own office. He accorded equal importance to aesthetic quality and function, employing such new materials as metal, tubes and glass. The chrome-plated lamp is by Jacques Le Chevallier (1927; Martel Collection), the carpet by Fernand Léger.

37. Le Corbusier, Jeanneret, Perriand. Armchair. 1928. Painted tubing and box. Charlotte Perriand Collection, Paris. The prototype of one of the chairs made by Thonet. It illustrates the theories of *L'Esprit Nouveau*, being designed as a functional object, not an aesthetic exercise.

38. Le Corbusier, Jeanneret, Perriand. Reclining chair (1966 copy). 1928. Chrome-plated and opaque black steel. Collection Formes Nouvelles, Paris. A new version of a 1928 model, made by Cassina in 1966. The chair is completely modern in spirit, being perfectly functional in its design.

39. Jean Prouvé. Chair. 1923. Tubular, folded and soldered metal plate. The artist's collection. In 1923 Prouvé began to use purely industrial techniques and materials to produce furniture, as in this example.

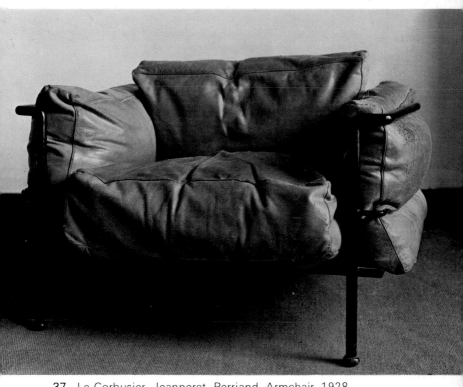

37. Le Corbusier, Jeanneret, Perriand. Armchair. 1928.

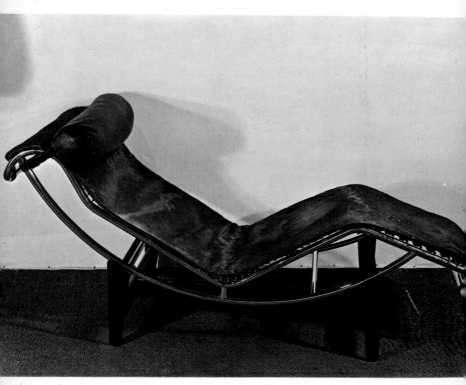

38. Le Corbusier, Jeanneret, Perriand. Reclining chair (1966 copy). 1928. Chrome-plated and opaque black steel. Collection Formes Nouvelles, Paris.

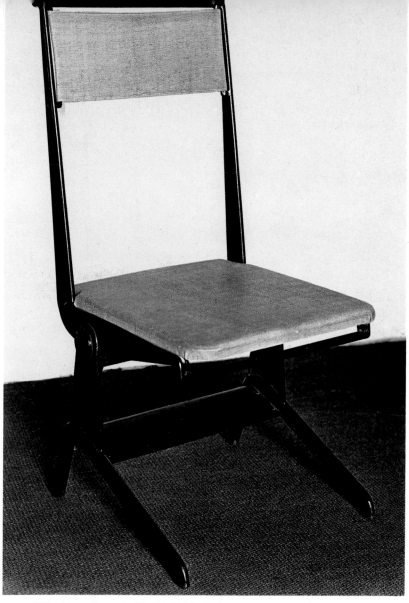

39. Jean Prouvé. Chair. 1923. Tubular, folded and soldered metal plate. The artist's collection.

and who recognised the predominance of form over décor.

THE POSTER

The modern advertising poster is a product of the industrial age, of mass-production techniques, large-scale printing and a growing public appetite for entertainment. In the late 19th century, poster art had benefited by the discovery of Japanese prints and the painted banners carried through the streets in Japan to announce theatrical performances. By about 1900, a number of artists belonging to the different schools and movements had interested themselves in poster design. Jules Chéret gave the poster a character that was at once synthetic and symbolic. Later it moved more markedly in the direction of Symbolism in the work of Maurice Denis, before becoming influenced by Japanese art in the designs of Bonnard and the Nabis. Grasset, De Feure and Mucha adopted the decorative style of Art Nouveau; the posters of Toulouse-Lautrec and his contemporaries Steinlen and Forain had tended towards Expressionism. Finally, links between poster art and Fauvism became apparent in the work of Cappiello, who remained a powerful influence until 1914.

Cassandre's first poster, *Le Bûcheron,* appeared in 1923. It announced a new style, in harmony with the age, in which advertising had begun to play an essential part. 'Clarity, schematicism, dynamism (the word was becoming fashionable), perceptible symbolism, vigour of execution—they were all there', wrote Bernard Champigneulle in his catalogue preface for the exhibition of Cassandre's posters at the Musée des Arts Décoratifs in Paris (1951). Adolphe-Jean-Marie Mouron, known as Cassandre, was born of French parents at Kharkov in 1901. From the beginning of his career he found a style that corresponded to 'the age of jazz and cubism'. 'Publicity', he said, 'is not a medium for self-expression, it is a means of communication between the seller and his public, rather like telegraphy . . .' Until his departure for the United States in 1936, he remained faithful to the same principles: 'since a poster is a way of addressing a hurried passer-by, already harassed by a jumble of images of every kind, it must provoke surprise, rape his sensibility and mark his memory with an indelible imprint. An ingenious idea capable of striking the passer-by like a blow of a fist is not enough; the right way of expressing the idea must be found; brutality perhaps, but also style' (Champigneulle). At the 1925 Exhibition, Cassandre won the *grand prix* for poster art and went on to make

many designs, personally supervising their lithographic execution. His works include *Pivolo* (1925), for an *apéritif* poster, in which he used intense black and white contrasts, *L'Etoile du Nord* (1927) for Pullman trains, and *LMS* (1928) for the English railway company; in the last two the main subject was treated in a pure geometrical style, the letters being imaginatively integrated into the overall composition. Cassandre was passionately interested in typography, and in 1929 designed his *Bifur* lettering for Deberny and Peignot, giving them an advertising typeface which has remained a graphic symbol of the style of the 1920s. In 1930, in collaboration with Charles Loupot and M. A. Moyran, he founded the Alliance Graphique, which published a large number of his posters.

Loupot created some of the most famous posters of the post-war period, notably those for the Exhibition of Decorative Arts (1925) and the Voisin car, the *Valentine* for a famous brand of paint and the *Bonhomme en bois* for the Galeries Barbès. He was especially successful in designs with clearly defined, contrasting forms and colours.

Paul Colin made his debut as a poster designer in 1925, with his *Maya* and *Revue Nègre* for the Théâtre des Champs Elysées, followed by posters for *Josephine Baker* (1925) and the *Nuit du Théâtre à Luna Park*

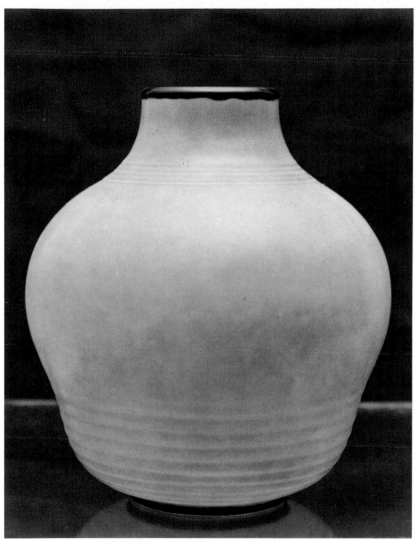

40. Emile Decoeur. Vase, *c*. 1925. Enamelled sandstone
(20 x 18 cms). Musée des Arts Décoratifs, Paris.

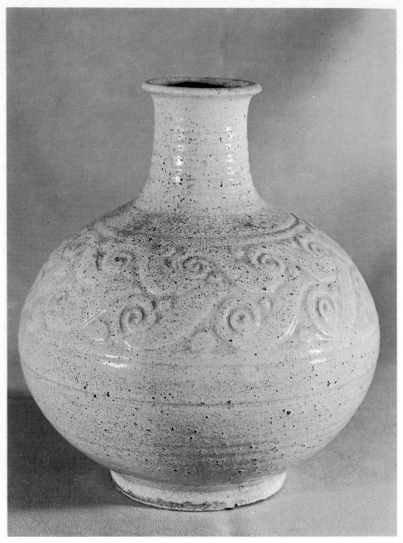

41. Emile Lenoble. Vase, *c.* 1912. Incised and enamelled sandstone (29.5 x 25 cms). Musée des Arts Décoratifs, Paris.

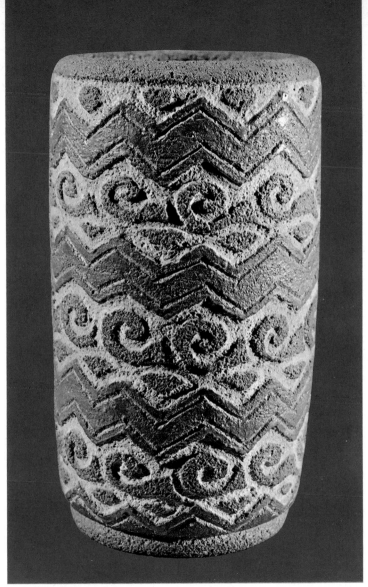

42. Georges Serré. Vase, *c*. 1927–1929. Sandstone with
oxide colours and incised decoration (20.5 x 11.5 cms).
Musée des Arts Décoratifs, Paris.

40. Emile Decoeur. Vase, *c*. 1925. Enamelled sandstone (20 x 18 cms). Musée des Arts Décoratifs, Paris. The vase belongs to the period of Decoeur's greatest achievements; he sacrificed decoration to purity of form and beauty of enamelling.

41. Emile Lenoble. Vase, *c*. 1912. Incised and enamelled sandstone (29.5 x 25 cms). Musée des Arts Décoratifs, Paris. Lenoble succeeded in harmonising materials, forms and decoration. He incised geometrical and floral patterns on the sandstone, and sometimes on the enamel, to emphasise the shapes of his vases. In this case, the decoration consists of parallel stripes and restrained interlacing curvilinear patterns.

42. Georges Serré. Vase, *c*. 1927–1929. Sandstone with oxide colours and incised decoration (20.5 x 11.5 cms). Musée des Arts Décoratifs, Paris. Between 1927 and 1930 Georges Serré produced works with geometrical decorations using enamels or oxide colours, deeply incised in earthenware mixed with fireproof clay.

43. André Methey. Plates. 1908. Faience (diameter 23.2 cms). Musée des Arts Décoratifs, Paris. To reinvigorate the old tradition of French faience. Methey had his ware decorated by painters. The plate on the left is decorated by Derain; the one on the right by Vlaminck.

43. André Methey. Plates. 1908. Faience (diameter 23.2 cms). Musée des Arts Décoratifs, Paris.

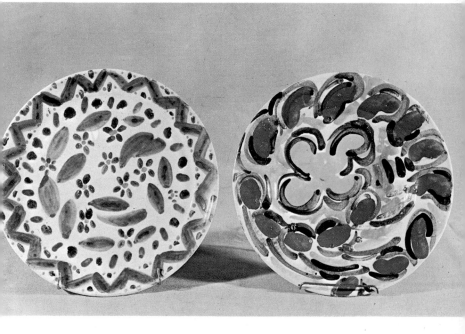

(1928). 'In these transcendant riddles in which line and colour contributed to the overall effect, and in which the inexpressible played such an important part, he was undoubtedly a past master' (Robert Rey's preface to the Paul Colin exhibition, Musée des Arts Décoratifs, Paris, 1949).

The development of poster design in the 1920s paralleled that of the great companies, tourist resorts, and the world of the theatre. As in 1900, poster art attracted artists of very different temperaments and styles. From 1922 to 1930, René Vincent made a great number of designs for the Bon Marché department store, Philips Radio and various automobile companies including Voisin. Apart from their work as illustrators and fashion draughtsmen, André E. Marty and Georges Lepape designed posters for the theatre and fashion shows: *Les Ballets Russes* (1911) by Marty; *Spinelly* (1914), *Le Tour d'Europe de Paul Poiret* (1920) and *Soirée de Gala au Théâtre des Champs-Elysées* (1924) by Lepape. Charles Dufresne, Gesmar, Goncharova, Herbin and André Lhote were among those who designed posters for every kind of amusement. Their designs, with clear-cut contrasts of forms and colours replacing the arabesque patterns of the 1900s, gave the post-war street an appearance quite unlike anything that had previously been seen in France.

BOOK-BINDING

The art of book-binding owed its revival to Jacques Doucet, a couturier and collector who had wanted new bindings of modern design for his manuscripts and first editions of contemporary authors. He first thought of asking André Mare, who was then in the forces, but finally turned to Pierre Legrain (1889–1929), a young decorative artist working with Iribe. At Doucet's request, Legrain designed his first binding for Francis Jammes' *Pensée des Jardins* in 1917—the accidental beginning of a career which revolutionised the art. His designs were executed by the binders Canape and Noulhac, and above all by René Kieffer, with whom he began to work regularly after 1919, when he left Jacques Doucet. His clients included the collectors Henri de Monbrison, Robert de Rothschild, A. Bertaut, Baron Gourgaud and Robert Azaria, and he exhibited regularly in the salons. His ignorance of binding techniques served him well at the beginning of his career, since it allowed him to make free use of his imagination, inventing a new style that owed nothing to his predecessors' methods and was free from the floral decoration which had been dominant for more than a quarter of a century. He first used simple graphic designs, as in his binding for Gide's *Immoralist*;

as the bookseller Georges Blaizot remarked, 'From typical flora there was a transition to the rimy filigree of a Nordic spring.' From 1920 he created sumptuous new designs which depended on geometrical forms and unusual binding materials such as mother-of-pearl, wood, and sharkskin. He was the first binder to use lettering as the point of departure for the decoration. For Legrain 'a binding has no significance in itself. The flat cover of a book is nothing but a frontispiece which sums up the spirit of the book and prepares us to read it through the choice of a shading or a sign.' Although his first work was received with suspicion because of its novelty, Legrain triumphed at the exhibition of 1925 and was a source of inspiration for a group of young women who had been trained at the Ecole d'Art Décoratif in the Rue Beethoven, especially Jeanne Langrand and Rose Adler.

The career of Rose Adler (1897–1959) was also linked with the patronage of Jacques Doucet, for whom she worked from 1923 until his death in 1929. She was a pupil of the binder Noulhac, and quickly became known for her individual sense of colour and choice of materials. Doucet noticed her at an exhibition organised by the school in the Rue Beethoven at the Pavillon de Marsan in 1923, and thereafter she fell under his influence as well as that of Legrain.

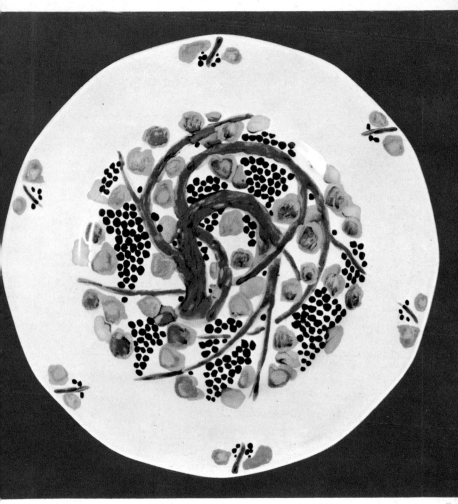

44. Suzanne Lalique. Plate, *c*. 1925. Porcelain of Théodore Haviland, Limoges (diameter 25 cms). Musée des Arts Décoratifs, Paris.

44. Suzanne Lalique. Plate, *c*. 1925. Porcelain of Théodore Haviland, Limoges (diameter 25 cms). Musée des Arts Décoratifs, Paris. Suzanne Lalique and Jean Dufy (the brother of Raoul Dufy) were the best painters working for Haviland in the 1920s. Lalique's art is at once formally elegant and refined.

45. François-Emile Décorchemont. Vase, *c*. 1920. Marbled and incised glass paste (21 x 22 cms). Musée des Arts Décoratifs, Paris. A beautiful example of Décorchemont's post-war work. He abandoned soft glass and subjects in the manner of the 1900s in favour of thick coloured glass paste with geometrical incised decorations and geometrically stylised flower motifs superimposed.

46. René Lalique. 'Senlis' vase, *c*. 1925. Smoked glass. Marie-Claude Lalique Collection, Paris. Lalique had a predilection for ample (but not heavy) spheroid forms and clear, lightly coloured blue or brown glass.

47. Maurice Marinot. Flasks, *c*. 1928–1930. Clear glass (11.5 x 8.5 and 15 x 9.5 cms). Musée des Arts Décoratifs, Paris. In 1927 Marinot began to model glass in the furnace—flasks with simple forms, their thin necks topped by round stoppers. Decoration is almost entirely absent, with enamel inserted between two layers of plain glass.

48. Baccarat. Perfume flasks. 1925. Crystal (heights 12, 15 and 11 cms). Musée des Arts Décoratifs, Paris. The perfume flasks were designed after models by Georges Chevalier and presented at the 1925 Exhibition. They exemplify the stylised forms adopted by the Baccarat crystal factory in 1910.

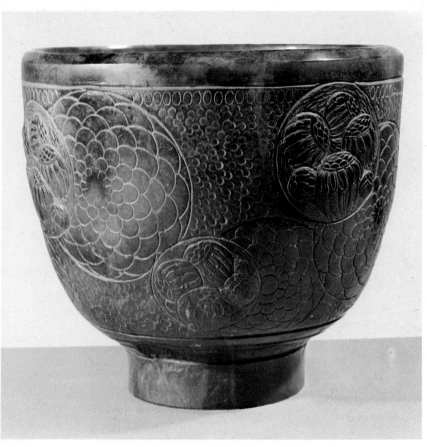

45. François-Emile Décorchemont. Vase, *c.* 1920

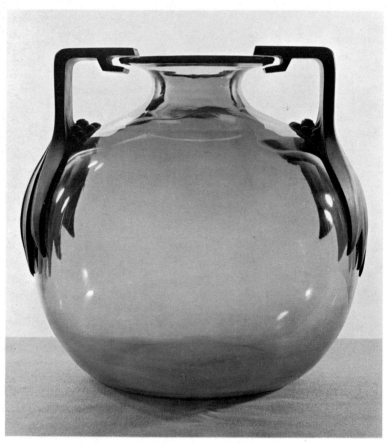

46. René Lalique. 'Senlis' vase, c. 1925. Smoked glass.
Marie-Claude Lalique Collection, Paris.

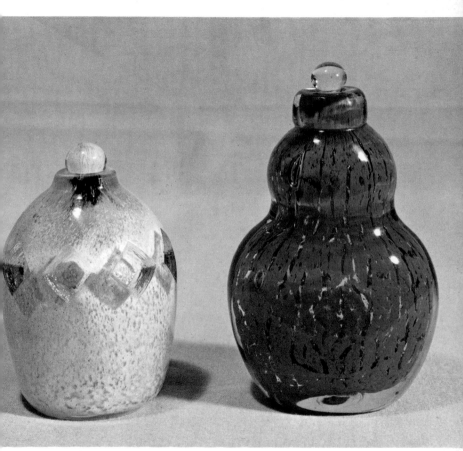

47. Maurice Marinot. Flasks, *c*. 1928–1930. Clear glass
(11.5 x 8.5 and 15 x 9.5 cms). Musée des Arts Décoratifs,
Paris.

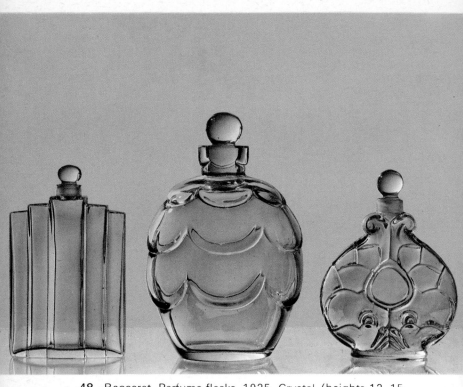

48. Baccarat. Perfume flasks. 1925. Crystal (heights 12, 15 and 11 cms). Musée des Arts Décoratifs, Paris.

From 1924 to 1929 she developed her own style with allusive works employing geometrical forms in supple reptile skins and metallised calf-skin encrusted with precious stones. In 1930 she became an associate of the artists of the Union des Artistes Modernes.

Following Legrain, a group of young artists assured the triumph of the new style. Among them was Fernand-Louis Schmied, a Swiss painter who designed bindings decorated with Jean Dunand's lacquers, and Robert Bonfils, who had met and become the friend of Pierre Legrain in 1903, at the Ecole Germain Pilon. Love of illustrated books led Bonfils to take up binding, which he approached as a colourist and graphic artist, trying to create harmonies based on materials. The traditional technique of binding was revived in floral decorations in a more modern style in the work of Georges Cretté.

André Mare (1887–1932) occupies a place apart in the book-binding history of the period. A painter and decorator, Mare designed his first bindings in about 1910–1911, at the same time as he was participating in the already described battle over the decorative arts. His style attempted to reconcile tradition and modernism; he covered his books and writing pads with 'Cubist' roses, garlands, figural motifs and vividly coloured compositions on a background of parchment. His style was in direct contrast to that of

Pierre Legrain, who represented the modern tendency.

FASHION

It is impossible to devote even a few pages to the 1920s without mentioning fashion, for it was in a revolutionary phase reflecting the profound changes taking place in social life, and particularly in the lives of women. It was also sensitive to the influences at work in ideas, literature, theatre and plastic arts. The couturiers who dictated fashion were not content to define the character of the age; they also participated in artistic movements. This was the case with Paul Poiret, Jacques Doucet (who was a patron of painting, interior decorating and furniture, as well as book-binding), and Jeanne Lanvin, who made Armand Rateau, the decorator of her house in the Rue Barbet-de-Jouy, the manager of an interior-decoration workshop.

In 1902 the 'wasp-waist' style for women's clothes had begun to be abandoned. The tailored two-piece suit with a hem two or three inches above the ground and the first motoring suits were launched. The Directoire and Empire styles came back into fashion. Poiret asked Paul Iribe to design models inspired by

Directoire and Neo-Greek forms for him: Iribe's *The Dresses of Paul Poiret* was published in 1908 and gave its sanction to the loosely-fitted dress. The Ballets Russes quickly influenced the colour of such dresses, and the couturier derived from Bakst the idea of the 'mood' dress, designed to suggest 'a state of mind by means of unity of effect' (Luc-Benoist).

Excessive ornamentation disappeared from dresses; single-colour cloths or contrasts of bright colours replaced the soft tones popular in the early years of the century. Hobble skirts gathered at the ankle became fashionable, and everyday dresses were split, hidden folds in the seams making it possible to walk. Kimono blouses were adopted to allow freedom of movement, and stockings with simple embroidered clocks appeared with the freeing of the ankle and the replacement of boots by low shoes. Evening dresses remained long, with flowing trains.

The War accelerated the emancipation of women, who played a new and active part in social life and required a different type of clothing. Fashion developed outside the great fashion houses, which had closed down. Skirts became shorter and diversity of costume increased. With the return of peace, not all couturiers accepted the fashions adopted by the new emancipated woman who worked for a living and loved dancing and sport. The new houses that

opened were often managed by women: Mme Paquin, Madeleine Vionnet, Jeanne Lanvin and Chanel.

Post-war fashion banished the corset. Dresses were manufactured without waists or bosoms, and became shorter and shorter. Short hair styles were hidden by cloche hats low on the forehead, shoes were very low-cut and silk stockings became common. Evening dresses were short, without fastenings, and covered with pearls and spangles.

Textiles followed fashion and were also susceptible to outside influences. Supple, light materials like muslin and *crêpe* were needed for straight, free-flowing dresses. Sports clothes required fabrics of a new type, produced after experiments by Rodier and others. Manufacturers employed artists: Raoul Dufy worked for Bianchini-Férier, Dubost for Ducharne and Beaumont for Cornille. Geometrical and linear designs became popular. After the War, Sonia Delaunay designed highly coloured or black-and-white 'simultaneist' textiles and dresses (the word was used by Robert and Sonia Delaunay to describe their paintings) that were adapted by the world of *haute couture*. She and Jacques Heim launched the revolutionary notion of 'off the peg' clothing.

In 1927 a reaction against the masculinity of women's clothes brought Lanvin's embroideries

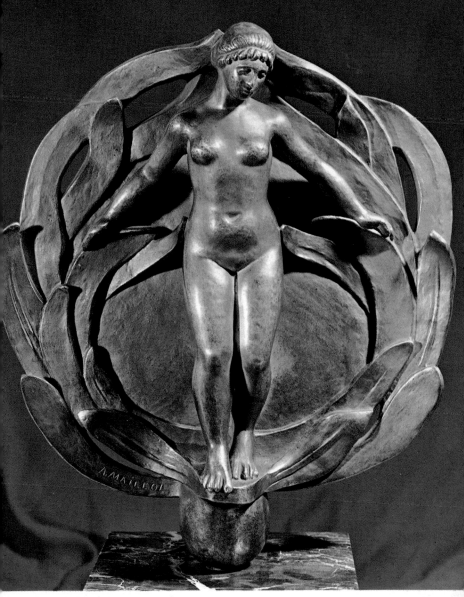

49. Aristide Maillol. Door-knocker. 1925. Gilded bronze.
Private collection.

49. Aristide Maillol. Door-knocker. 1925. Gilded bronze. Private collection. Made for the Fontaine pavilion at the 1925 Exhibition and sold by the firm of Fontaine.

50. Jean Dunand. Vase. 1914. Copper, silver, and iron bronzed and covered with a patina. (36.5 x 11 cms). Musée des Arts Décoratifs, Paris. This slender vase with its simple green and black stripes is a characteristic example of Dunand's stark, technically perfect style.

51. Jean Puiforcat. Teapot, c. 1925. Silver and crystal. N. Manoukian Collection, Paris. The beautiful undecorated form of this teapot exemplifies the qualities that made Jean Puiforcat the creator of modern French silverware.

52. Gio Ponti. 'Arrow' candlestick, c. 1927. Silver-plate. Collection of the Christofle firm. This was manufactured by Christofle in Paris and illustrates Ponti's 'modernist' tendencies. He was the most advanced Italian architect of the 1920s. combining Neo-Classical motifs with rational clarity of design.

50. Jean Dunand. Vase. 1914.

51. Jean Puiforcat. Teapot, *c*. 1925. Silver and crystal.
N. Manoukian Collection, Paris.

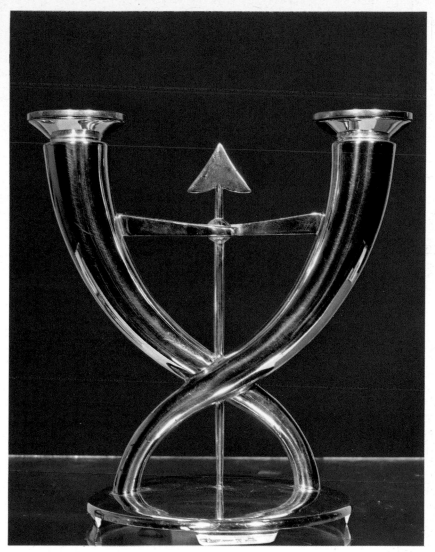

52. Gio Ponti. 'Arrow' candlesticks, *c*. 1927. Silver plate.
Collection of the Christofle firm.

and Vionnet's slanting cut and flowing dresses back into fashion. Skirts became longer, and evening dresses were made with low-cut backs. Chanel launched the style to which she has ever since remained faithful. At the end of 1929, femininity was emphasised still more, and hair was again worn long; the bright colours inspired by the Ballets Russes were replaced by more delicate tones.

CARPETS AND TAPESTRIES

The carpet has a function and requires a technique that has often been misunderstood in the West. In about 1900, a few artists like De Feure and Colonna tried to free carpet design from the influence of the Savonnerie works which was more interested in imitating painting effects than producing suitable floor-coverings.

The following generation also made a contribution. Decorative artists—Maurice Dufrène, Paul Follot, Louis Süe and André Mare, Nathan, Coudyser, Ruhlmann, André Groult—made carpet designs as part of their work on interior designs; the knotted carpet blossomed with flowers again in the best French tradition. Edouard Bénédictus designed both knotted carpets, and Jacquard moquettes in a

similar style distinguished by its fresh colouring. Before 1914, the floral decorations of the pupils of the Atelier Martine gave carpet design a really new look thanks to their freedom and lively range of colours.

Successive exhibitions of Moroccan art (1917, 1919, 1923) revealed the thick woollen piles and brown and red geometrical patterns of Berber carpets to the public. They inspired a style of which the leading practitioners were Silva Bruhns and Stéphany. The combination of this influence with that of Cubism produced the beautiful carpets designed by Robert Mallet-Stevens and Fernand Léger, and those that Jacques Doucet had made after Gustave Miklos's cartoons for the Studio de Neuilly.

The factories took part in this renaissance of carpet design, commissioning contemporary artists; the Savonnerie used designs by Robert Bonfils and Gaudissart, and the Beauvais carpet factory those of Bénédictus. The Maison Pépin et Berthier, which was founded in 1916 at Pau, commissioned work from Paul Follot, Süe and Mare.

A similar attempt at renewal was made by the administrators of the tapestry factories. Tapestries were made at Gobelins from cartoons by Robert Bonfils, Jaulmes, René Piot and Roussel, who took their subjects from contemporary life. The woven upholstery for chairs and screens produced by the

Beauvais workshops from 1914 was designed by Charles Dufresne, Jaulmes, Paul Véra and Raoul Duft. The two national factories began to collaborate, and were henceforth to participate in common enterprises. But it was significant that, apart from Raoul Dufy, none of the really influential painters were commissioned by the state; both Léger and Picasso were privately commissioned.

Credit for the beginning of the revival of tapestry design must go to such independent workshops as Gustave Jaulmes's at Neuilly, directed by his wife, and Manzana-Pissarro's at Aubusson. Georges Manzana-Pissarro (1871–1961) was the son of the famous painter. He and his wife set up a workshop at Aubusson before the First World War, producing tapestries based on his designs; gold, silver and silk used with wool in vivacious compositions with animals, birds and exotic female figures. After the War, the director of the Ecole d'Art Décoratif of Aubusson commissioned cartoons from painters such as Paul Véra, limited the colour range, and increased the size of the stitch. In 1926 Luc-Benoist thought that even the technique of tapestry was obsolete. 'It is to be feared', he wrote, 'that the apparent renaissance of the needle is nothing but an accidental survival.' A few years later Jean Lurçat was to prove him wrong.

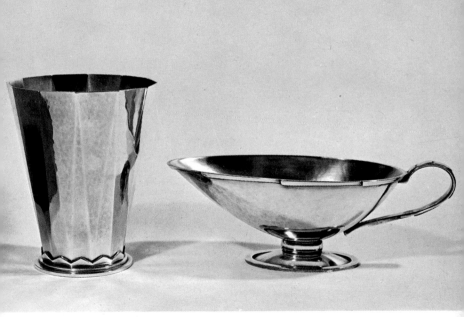

53. Christian Fjerdingstad. Goblet and sauceboat. 1925.
Silver plate (14 x 11 and 7.7 x 22.5 cms). Musée des Arts
Décoratifs, Paris.

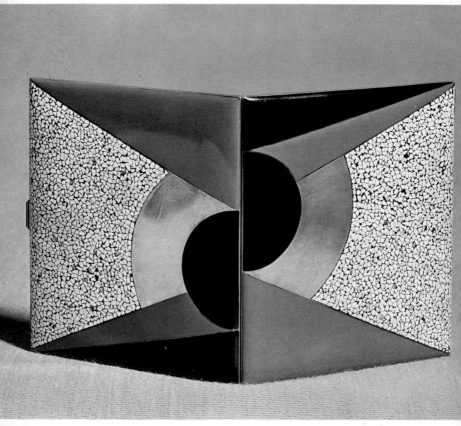

54. Raymond Templier. Cigarette case. 1930. Lacquer, silver
and eggshell. The artist's collection.

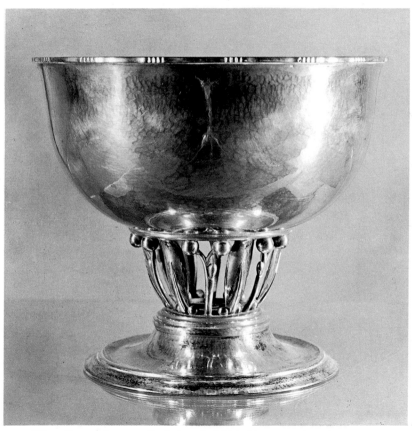

55. Georg Jensen. Fruit bowl. 1914. Hammered and
embossed silver (16.5 x 19.3 cms). Musée des Arts
Décoratifs. Paris.

53. Christian Fjerdingstad. Goblet and sauceboat. 1925. Silver plate (14 x 11 and 7.7 x 22.5 cms). Musée des Arts Décoratifs, Paris. Two pieces designed by the Danish silversmith Fjerdingstad and made in France by Christofle. They demonstrate the striking advances made in the design of Danish silverware after the First World War.

54. Raymond Templier. Cigarette-case. 1930. Lacquer, silver and eggshell. The artist's collection. In the 1920s Templier was regarded as a daringly modern jeweller. His style is well represented by this cigarette-case, its geometric forms made with contrasting materials.

55. Georg Jensen. Fruit bowl. 1914. Hammered and embossed silver (16.5 x 19.3 cms). Musée des Arts Décoratifs, Paris. The silversmith Jensen, who exhibited for the first time at the Salon d'Automne of 1913, was one of the first craftsmen who tried to revive the silversmith's art, which was being compromised by mass-produced machine-made products.

56. Orrefors. Carafe and flask. 1925. Cut glass (26 x 14.5 and 14.5 x 9 cms). Musée des Arts Décoratifs, Paris. The Swedish glass-making firm of Orrefors attracted attention at the 1925 Exhibition thanks to its cut-glass wares, which included the objects reproduced here.

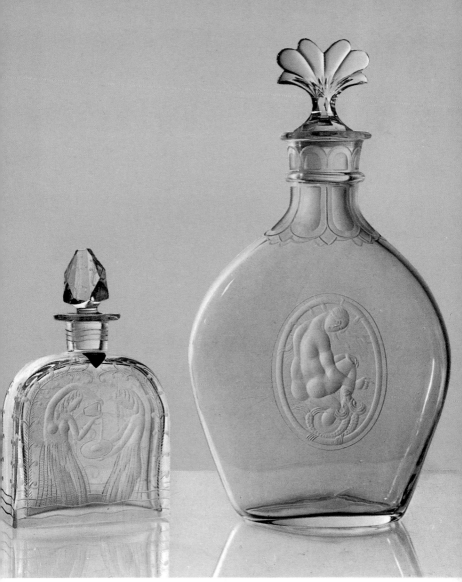

56. Orrefors. Carafe and flask. 1925.

UPHOLSTERY AND WALLPAPER

Decorative artists paid as much attention to curtains, chair covers and wall hangings as they did to furniture; hence some upholsteries and wallpapers carry the signatures of the same artists as pieces of furniture. From 1910 the influence of the Ballets Russes and the Werkbund prompted some manufacturers to launch silks designed by contemporary painters and decorative artists. Cornille, Chatel, Tassinari and Bianchini-Férier were among those thus employed. The Ballets Russes 'style' was successfully adapted to French taste by Paul Iribe, who influenced pattern-books published in 1913 and 1914. But it was only with difficulty that an original modern style came into being. At first it was a hybrid style, as was apparent in the work of Coudyser, Paul Follot and his collaborators in the Pomone workshop, Dufrène, and Bénédictus; they produced a variety of motifs ranging from Art Nouveau to others derived from Cubism. Such novelty as there was lay in the treatment rather than the design. The favoured themes were flowers and fruits, interpreted in a rustic manner by André Mare, and on a large scale by Kohlmann. On the eve of the First World War, two artists particularly distinguished themselves in this field: Poiret with the textiles of the Atelier Martine, and Francis

Jourdain. Raoul Dufy designed the beautiful silks printed by Bianchini-Férier (*Longchamps, Paris 1923, The Jungle*) and reconciled his colourist's temperament with the influence of Cubism and the demands of the material.

The textiles of Hélène Henry (1891–1958) represent a quite different tendency. She came to Paris in 1919 and set up a hand-weaving workshop; there she made silks and rayons in restrained colours—on a base of white, yellow, brown or grey—with barely discernible geometrical patterns. She worked mainly with the 'modern' decorators Francis Jourdain, Mallet-Stevens and Pierre Chareau, and was one of the founders of UAM.

A return to the principles of wood engraving and block printing brought new vitality to printed textiles. Before 1910, Jaulmes, Boigegrain and Victor Menu had founded the Société des Toiles de Rambouillet, which they provided with flower compositions in which roses predominated. André Groult published his own drawings as well as those of Iribe and Drésa. For them, colour was the most important element, as it was for the Atelier Martine and Francis Jourdain, who stencilled his designs. An anecdotal style attracted some artists, including Robert Mahias, Paul Follot and Maurice Dufrène. The most beautiful work was again that of Raoul

Dufy, who designed animated scenes in black and white, red and white and yellow and white.

Bianchini-Férier printed designs in which 'a balance is attained, and a transition established between line as significant in itself and line as evocative of images and ideas' (Luc-Benoist). These designs included *The Harvest*, *Fishing*, *Dance* and *Tennis*. Drawings by Mare, Marty (*Sports*, *Seasons*), Ruhlmann and Charles Martin were also printed on cotton and silk.

The development of wallpaper paralleled that of printed textiles; techniques and artists were practically the same, and the same designs were sometimes used for both materials. Wallpaper was again block-printed, though industrial production (of which Isidore Leroy was the best representative) was not totally abandoned. The Atelier Martine's dazzling designs, printed by Paul Dumas, featured flowers, branches and plants (eucalyptus, pink roses, etc.) and astonishingly refined nettles in black, white and silver. The Société Follot printed designs by Stéphany, Bénédictus, and Paul Follot. Besides his tapestries, Groult also printed wallpapers, and his collection included compositions by Marie Laurencin (*Les Singes*, *Arlequin*). The decorator René Gabriel began by printing and selling his own designs in his boutique 'Au Sansonnet'; he then supplied the

57. Marcel Breuer. Dining-room. 1926. Chrome-plated metal, black and white lacquered wood. Mme Kandinsky Collection, Paris.

57. Marcel Breuer. Dining-room. 1926. Chrome-plated metal, black and white lacquered wood. Mme Kandinsky Collection, Paris. The set, consisting of a round table and six chairs, was designed according to Kandinsky's instructions by Breuer at Dessau. On the wall is Kandinsky's *On White*, painted at Weimar in 1923.

58. Ludwig Mies van der Rohe. Table and chair. 1927. Nickel-plated steel tubing, black lacquered wood and rush seating. Bauhaus Archives, Darmstadt. This armchair, known as the 'Weissenhof-Sessel', was created for the Weissenhof exhibition at Stuttgart, where Mies van der Rohe built a block of high density steel-frame houses.

59. Ludwig Mies van der Rohe. Chair and stool. 1929. Special chrome-plated steel and leather. Musée des Arts Décoratifs, Paris. The production of the chairs made for the German pavilion at the Barcelona Exhibition (1929) has been taken up again by Knoll International. The designs illustrated mark an epoch in the history of art.

58. Ludwig Mies van der Rohe. Table and chair. 1927.

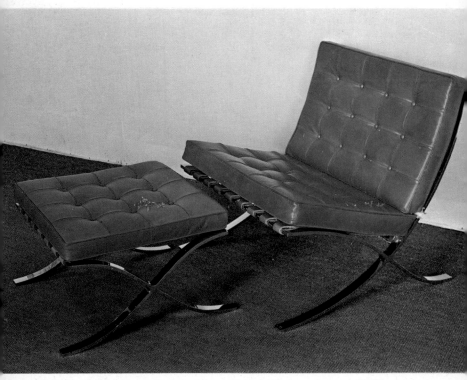

59. Ludwig Mies van der Rohe. Chair and stool. 1929.
Special chrome-plated steel and leather. Musée des Arts
Décoratifs, Paris.

Papiers Peints de France with small-scale, geometrical, floral and anecdotal patterns. Among the artists and decorators who had been attracted to this difficult art, which requires a careful distribution of colours and clear, well-ordered compositions, were Ruhlmann, Paul Véra, Charles Martin, Jean Lurçat and Robert Mallet-Stevens.

On the whole, however, only a few modern artists took any interest in wallpaper. Following the lead given by Le Corbusier, they replaced it by light monochrome (preferably white) paint. In his *Decorative Art of Today*, published in 1925, the architect made a profession of faith that was to damage the art of wallpaper. Writing about the effects of his 'Law of Ripolin', he says, 'Imagine the effects of the Law of Ripolin. Every citizen is obliged to replace his hangings, his damask, his wallpaper, his stencils, with a pure layer of white Ripolin. You are bringing cleanliness to *your own house*: there are no longer any dirty corners or dark corners: *everything shows itself as it is*. Then you clean *inside yourself*; for you will start refusing to admit anything that is not licit, authorised, wanted, desired, or conceived: you only act once you have conceived an idea. When shadows and dark corners surround you, you are only at home as far as the blurred edges of the obscure areas . . . you are not the master in your home. After painting your walls

with Ripolin, you will be *master in your home*. You will want to be exact, to be right, to think clearly. After your work, you will tidy up, you will see what it has produced; you will throw out the useless, you will again make up your balance sheet and carry the balance forward.'

FURNITURE

More than any other branch of decorative art, furniture reflected changes in fashion and style. It directly affected the buyer's comfort and therefore had to adapt itself rapidly to changes in the way people lived; and it was of course conditioned by building styles. Furniture techniques were transformed by new technical advances, and profited from new inventions and materials. The history of French furniture from 1910 to 1930 is also the history of French decorative art of the period, with all its diversity and complexity; and it was the decorative artist's first and foremost concern. Architects also became interested in furniture design, sometimes producing works of great importance.

The result was an abundant furniture production by artists who may be divided into two categories: the traditionalists, who tried to reconcile themes,

forms and techniques taken from the past with modern life; and the innovators or moderns, who resolutely rejected the past, accepted the present with all its formal problems and technical possibilities, and were already creating the art of the future. The traditionalists generally aimed to produce highly refined pieces by applying a perfect technique to selected materials: woods (rosewood, mahogany, macassar, violet wood, sycamore, elm), sharkskin, lacquer, metals (silver, iron, copper, aluminium), glass, ivory, mother-of-pearl and tortoiseshell. When grain contrasts in wood were not exploited for their effect, woods were carved, encrusted or inlaid. Drawer handles or rings were made of ivory, bronze or fretted metal. It is difficult to distinguish typical forms for 'traditionalist' furniture since they varied according to the character and purpose of each piece, and the personality of each artist.

Paul Follot (1877–1941), a pupil of Grasset, was influenced by the Pre-Raphaelite movement and English styles. He was fond of beautiful materials and precious techniques (marquetry, lacquer, bronze work), colour, and frequently lavish decoration that was usually carved. In 1923 he took over the management of the Pomone workshop in the Bon Marché store, and was in charge of its pavilion at the 1925 Exhibition. Follot was the defender of the *de luxe*

60. Gunta Stolzl. Tapestry. 1927–1928. Wool on a flax weft. (130 x 110 cms). Bauhaus Archives, Darmstadt. After being a pupil at the Bauhaus between 1919 and 1925, Gunta Stolzl became an instructor in the tapestry workshop at the Dessau Bauhaus from 1926 to 1932. He wove beautiful tapestries with geometrical patterns.

61. Joseph Albers. Teacup. 1925. Glass, wood and metal. Bauhaus Archives, Darmstadt. Albers was a student at the Bauhaus before becoming a teacher in the glass workshop there; he finally became director of the design and furniture department. He designed everyday objects in an absolutely modern style.

62. Marianne Brandt. Ashtray and small teapot. 1924. Alloy of silver and Britannia metal. Bauhaus Archives, Darmstadt. A pupil at the Bauhaus, Brandt worked in the metal workshop with Moholy-Nagy and conducted research into the use of new materials.

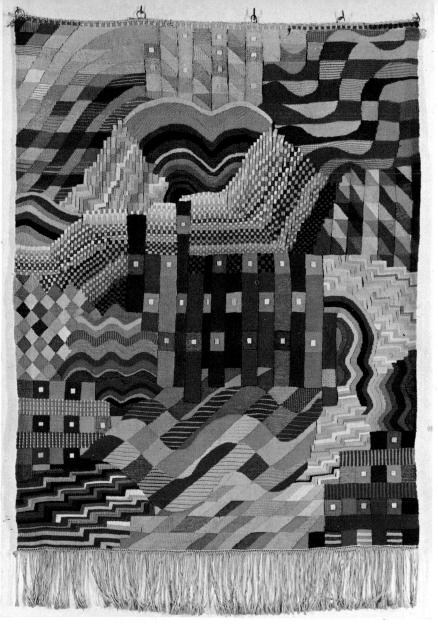

60. Gunta Stolzl. Tapestry. 1927—1928.

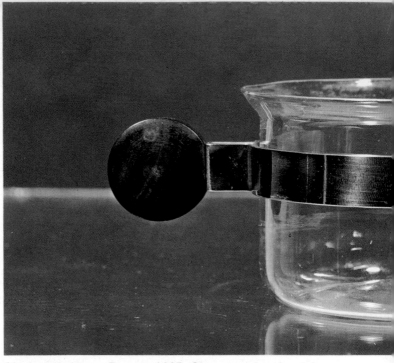

61 Joseph Albers. Teacup. 1925. Glass, wood and metal.
Bauhaus Archives, Darmstadt.

62. Marianne Brandt. Ashtray and small teapot. 1924. Alloy
of silver and Britannia metal. Bauhaus Archives, Darmstadt.

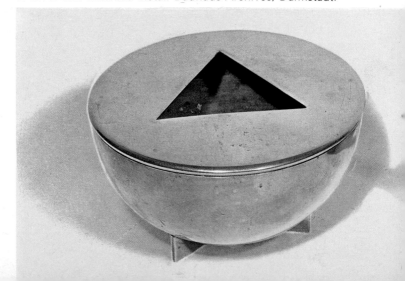

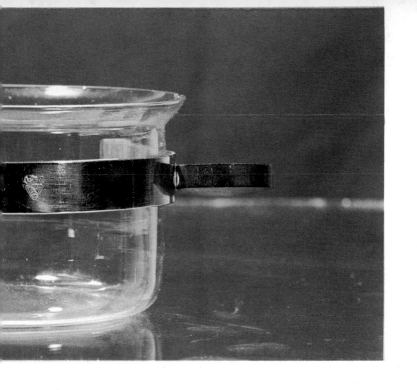

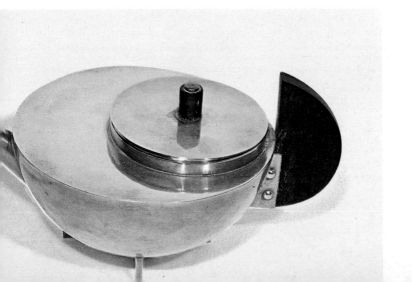

aristocratic tradition and was opposed to 'mass-produced art'.

Maurice Dufrène, the director of the La Maîtrise workshop in the Galeries Lafayette, was regarded as an ideal decorator for women; for them he designed 'bedrooms, boudoirs, drawing rooms, knick-knacks, chairs, divans and sumptuous, lightly embroidered cushions; his work was always distinguished and in the highest taste' (Pierre Olmer, 1925). These qualities are not so apparent today; for whether he was making cheap furniture or *de luxe* pieces, he was rather subservient towards prevailing fashions and his work was uncertain and commonplace in character.

Paul Iribe (1883–1935) was strongly influenced by the fluid forms of Art Nouveau, and his pieces were refined, comfortable and elegant. His chairs were enveloping, wide and ample; and all his furniture was embellished with beautiful materials and carved or encrusted ornaments—the Iribe rose being the most famous—and heightened with contrasting colours. In 1912 Jacques Doucet commissioned Iribe to furnish his apartment in the Avenue du Bois.

Clément Mère worked for the Maison Moderne for some time in the 1900s. From 1910 he exhibited finely executed knick-knacks, desks and cabinets, and showcases in various Salons. Their sober lines

were embellished with decorations executed by Mère himself: engraved ivories, rare inlaid woods, tooled leathers with patinas, and lacquers or imitations of veined, marbled lacquers.

André Groult based his work on the styles of the French Restoration and the 18th century, but he was able to create a personal manner adapted to the taste of the period. He had a predilection for ample forms and harmonious combinations of contrasting woods and colours. His furnishings for the Chambre de Madame in the pavilion of the French Embassy at the 1925 Exhibition illustrated his love for curvilinear baroque forms.

André Mare (1887–1932) made furniture inspired by provincial styles before founding the Compagnie des Arts Français in 1919 (with Louis Süe). It was in reaction against the 'monstrous extension of a single and same personality' which, the members believed, characterised Art Nouveau. Mare and Süe formed a team with Paul Véra, Jaulmes, Desvallières, Dufresne, Segonzac, Boutet de Monvel, André Marty, Pierre Poisson and Marinot, and attacked every aspect of interior decoration. They were not trying to create a fashionable or a revolutionary art but 'serious, logical and welcoming' interiors with the aid of tradition. Inspired by the forms of the Louis-Philippe period, the furniture of Süe and Mare displayed a

predilection for curves, monotinted veneers, lacquers, wood contrasts and carved details.

Emile-Jacques Ruhlmann (1879–1933) was trained as a cabinet-maker and was known from 1913 as a creator of luxury furniture. He favoured veneers of rare woods—amboyna, amaranthe, violet wood, macassar ebony—encrusted with ivories and materials like morocco leather and sharkskin. His simple, elegant, discreetly curved forms were recognisable by their spindle-legs. Towards the end of his life he made use of chromed metal and silver in the construction and decoration of his furniture. His choice of furniture was traditional: commodes, ladies' writing desks, secrétaires, occasional tables and flat desks.

Armand-Albert Rateau (1882–1938) belonged to no group or salon. His work reflected his profound love for antiquity and Oriental art. He worked with wood, especially solid oak, metal (gold and silver), and yellow and brown lacquers. In 1920–1922 he designed Jeanne Lanvin's apartment in the Rue Barbet-de-Jouy and her bronze furniture decorated with pheasants, daisies and butterflies. His ornate style gradually became more restrained, culminating in the remarkable sobriety of the mahogany furniture he made for Dr Thaleimer and Mlle Stern (1929–30).

Other artists who should be mentioned in this

section are Léon Jallot, André Domin and Marcel Genevrière, René Joubert, Montagnac and Henri Rapin. Three other decorative artists deserve special mention because of their work for Jacques Doucet, who chose them to decorate and furnish his Neuilly Studio (*c.* 1925): Pierre Legrain, Marcel Coard and Paul-Louis Mergier.

Legrain had been a decorator before he started book-binding. He had collaborated with Paul Iribe, and before the War took part in the furnishing of Doucet's apartment in the Avenue du Bois. For the Studio, in which paintings by Modigliani, Matisse, Picasso, Miró and Picabia hung beside African sculptures, he designed his favourite type of furniture: simple, rigid pieces, made of expensive and sometimes unusual materials: palm wood, macassar, ebony, metal, leather, silvered glass, waxed canvas.

Marcel Coard worked mainly for collectors; his production, very much influenced by his architect's training, was exclusively composed of unique pieces. He was the first designer to make furniture covered with leaves of parchment. His forms are deliberately heavy, and either curved or cubic.

Paul-Louis Mergier, by profession an aeronautical engineer, should also be mentioned; he specialised in soberly designed leather-upholstered furniture.

The innovators regarded furniture as an element

of interior architecture, and accordingly simplified its lines, volume and decoration. A few remained faithful to traditional materials like leather, but the majority used metal, especially painted hollow metal tubes, which could be mass-produced.

Francis Jourdain was the first decorator in France to tackle the problem of 'making the most of increasingly restricted space'. 'One can furnish a room very luxuriously by taking out furniture rather than putting it in.' His appreciation of this fact, and his determination to produce low-priced furniture for the general public, indicate that he was a precursor of the modern movement. Jourdain's furniture was entirely undecorated, being constructed with massive wood along simple geometrical lines.

Pierre Chareau looked at furniture with the eye of an architect, as a set of objects to be integrated with precision into a given environment. He preferred fine materials—mahogany, rosewood, ash and syca-more—and beautiful volumes which made all orna-ment superfluous. He was one of the first decorators to use plastic surfaces for children's rooms and bathrooms. In collaboration with Lipchitz, Jean Lurçat and Hélène Henry, he designed the office of the French Embassy at the 1925 Exhibition.

René Herbst was one of the artists responsible for the split in the Société des Artistes Décorateurs that

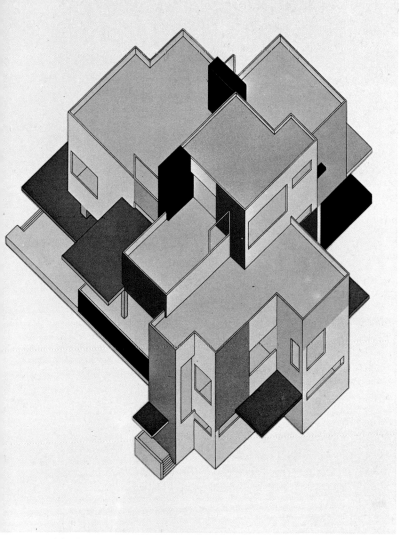

63. Theo Van Doesburg and Cor Van Eesteren. Architectural design. 1923. Lithograph (44 x 60 cms). César Doméla Collection, Paris.

63. Theo Van Doesburg and Cor Van Eesteren. Architectural design. 1923. Lithograph (44 x 60 cms). César Doméla Collection, Paris. Doesburg was the animating spirit of the De Stijl group. He and Van Eesteren have here given an outstanding example of how the three primary colours (red, blue and yellow) and the three 'non-colours' of Neo-Plasticism (black, white and grey) can be successfully combined in architecture.

64. Theo Van Doesburg. Architectural project. 1924–1925. Drawing (53.5 x 60 cms). Van Doesburg Collection. Design for the flower room of the Villa Noailles at Hyères, built in 1923 by Mallet-Stevens and further arranged by Djo Bourgeois in 1925.

65. Theo Van Doesburg. Tapestry. 1964, after a design of 1917. Wool (136 x 310 cms). Van Doesburg Collection. Woven in 1964 in the La Baume-Dürrbach workshop; after a design of 1917 for a mural decoration. This was intended for an interior belonging to the architect Oud, a member of the De Stijl group.

64. Theo Van Doesburg. Architectural project. 1924–1925.

led to the foundation of the Union des Artistes
Modernes. He was hostile to all superfluous decor-
ation, and a partisan of furniture and objects adapted
to their function. He experimented with prototypes
for rational furniture—chairs, desks, tables—in
which he made use of metal, steel and aluminium,
wood, and some new materials.

Robert Mallet-Stevens attracted attention as a
decorator at the 1913 Salon d'Automne, at which he
exhibited a hall and a music room. The fresh colours
and clear-cut design—and a certain austerity—made
a considerable impression on the public. First and

65. Theo Van Doesburg. Tapestry. 1964, after a design of
1917. Wool (136 x 310 cms). Van Doesburg Collection.

foremost an architect, Mallet-Stevens thought of furniture in terms of interior volume and soon made use of metal and painted and chrome-plated tubing.

Djo Bourgeois collaborated with Kohlmann and Mattet at the Studium, the decorative workshop in the Grands Magasins du Louvre. He evolved his own style in about 1925, with furnishings for the Villa Noailles at Hyères. From 1926 he used metal in soberly designed furniture with harmonious lines and surfaces.

Le Corbusier and his partners Pierre Jeanneret and Charlotte Perriand aimed to make objects in the

service of man and not of the decorative arts. In 1927–1928 he designed chairs and tables of various types which were manufactured by Thonet in tubing, metal and glass. The chair coverings were simple pieces of canvas held taut by spring-fastenings.

Finally, Jean Prouvé, the son of Victor Prouvé of Nancy, produced work that displayed his affinity with the spirit of the Bauhaus; as early as 1923 he made a chair using purely industrial materials and techniques.

POTTERY

The pottery of the 1920s benefited from the great revival of the late 19th and early 20th century. Ceramic designers had reacted against faience and painted porcelain, which had been imposed on French taste through the intermediary of Italian maiolica and Chinese porcelain, and against the bad copies that manufacturers had been turning out for fifty years. From the mid-19th century they had been trying to renew their links with the artisanal tradition of direct contact between craftsman, materials and firing-kiln; and the discovery of Japanese ware was a powerful impetus in the same direction. Designers came to believe that true beauty lay in objects made by

a craftsman, their shapes stressed by specially chosen enamels which emphasised rather than concealed the simplicity of the material. The banality and vulgarity of 19th-century industrial production made such an attitude necessary; only much later, after the modern revolution in the arts had taken place, could artist and industry come to terms.

Chaplet, Carriès, Bigot and Dalpayrat reinvigorated the tradition of stoneware and porcelain, combining Japanese influence with national sources of inspiration and themes inspired by nature, as in Art Nouveau. August Delaherche (1857–1940) was a representative figure of the 1900s. He continued to produce in the same vein in the 1920s, exerting a valuable influence through his craftsman's experience of stoneware and porcelain. From 1904 he showed greater interest in the forms and qualities of enamels, and his style evolved in the direction of modern simplicity of form. He introduced ceramics into architecture, making panels, friezes and mantelpieces.

The period between 1910 and 1930 was dominated by Decoeur and Lenoble. Emile Decoeur (1876–1953) was a faience maker who became attracted by sandstone. He made a thorough study of all the relevant techniques and made many experiments, producing tiger-ware; enamel vases with drip-glazes

(1905); incised and enamelled decorations with rose motifs, flowers and spirals, sometimes on incised backgrounds decorated with slip; and painted decorations (1910–1920). In about 1907 he made his first experiments with glazed porcelain with tiger-spots. The evolution of the two materials proceeded along the same lines; Decoeur applied the same decorations and the same enamels to his porcelain, which was generally thick, and to his sandstone wares. Decoration had no intrinsic value as far as he was concerned; it was determined by the shapes of his products, which consisted of spherical, short-necked vases, round vases, cups and plates. In about 1925 he created his purest masterpieces: vases, cups and bowls covered in magnificent yellow, blue, pink, green and white enamels, making all decoration superfluous.

Decoration came back into its own in the work of Emile Lenoble (1876–1940). It was geometrical or floral, perfectly adapted to the form and incorporated in the material, being either incised in the clay or slip, modelled in low relief, or painted under or over the glaze. After seven years' apprenticeship with an industrialist, Lenoble had learned faience techniques; he then acquired the techniques of sandstone and firing in Chaplet's firm, which he entered in 1904. From the beginning his experiments led him in a

different direction from that of his master. His friend Henri Rivière, a connoisseur of Oriental art, helped him to find his true vocation by introducing him to Korean and Sung pottery. His pottery—cylindrical vases, bottles, bowls—was made on the wheel; he sometimes mixed sandstone with kaolin to give it exceptional delicacy and lightness.

Of the many artists who followed the example of the pioneers of 1900, mention should be made of Henri Simmen, who covered his wares (made without a wheel) with crackle-glazes or sea-green glazes and coloured enamels; Jeanneney, a pupil of Carriès, whose work was strongly influenced by the Japanese; Raoul Lachenal, who worked in sandstone, with geometrical decoration sometimes executed in cloisonné with oxide enamels, and porcelain; and Séraphin Soudbinine, Rodin's favourite pupil, who tried to equal the ceramic art of China and Japan in his sandstone and porcelain ware, which he either turned on the wheel or hand-modelled, covering it with shiny varnish or thick crackled enamel. Georges Serré (1889–1956), a less well-known ceramicist, now appears at once original and representative of the period. In 1922, with the encouragement of Lenoble and Decoeur, he began to produce thick sandstone ware and (occasionally) vase-shaped or tubular baked clay ware incised with simple geometrical

motifs which were sometimes emphasised with oxides and enamels.

A passion for form and material did not totally eliminate a taste for decorated porcelain. Some artists chose faience with enamel on which they could paint with the aid of metal oxides. Discouraged by lack of success in his experiments, André Methey (1871–1921) abandoned sandstone in about 1906 and opened a faience workshop. To decorate his ware he called in the painters he had met through Ambroise Vollard: Redon, Rouault, Matisse, Bonnard, Vuillard, Valtat, Friesz, Derain and Vlaminck. Etienne Avenard's creations remained popular in style. In about 1913, he used his own garden clay, commercial enamels and oxides, turning and stamping vessels of various kinds (mainly bowls painted with little yellow, blue, green and red floral motifs).

Jean Mayodon hand-modelled or painted figures and animals on faience that had been made fireproof with particles of baked pulverised clay. The painter-engraver René Buthaud painted broadly outlined figures with brilliantly coloured enamels on squat massive forms. Jean Besnard, the son of the painter, preferred to use clear colours heightened with gold and silver.

Industrial ceramics benefited to some extent from the experiments and achievements of the masters.

They mainly consisted of tableware in which there was a discreet evolution of forms with regard to details; curved lines were gradually replaced by angles. Renewed vitality was more apparent in decoration. Théodore Haviland, working at Limoges, commissioned Suzanne Lalique, the daughter of the glass-maker, and Jean Dufy, Raoul's brother. The dealer Géo Rouard produced faience table services with flower, butterfly and animal decorations by Marcel Goupy. In 1911 Jean Luce tackled the twin problems of form and decoration; his hand-painted or stencilled motifs were linear or naturalistic, very much in the modern style, and embellished with gold in the case of more luxurious objects.

Provincial faience manufacturers in Alsace, Brittany and the region of Paris (Montereau, Creil, Choisy-le-Roi) took part in the movement of renewal. So did the workshops of Parisian department stores, especially the Primavera and Süe and Mare's Compagnie des Arts Français, who produced table services and other objects to complete their furnished interiors. In his shop in the Rue de Sèze in Paris, Francis Jourdain sold services in faience and glazed earthenware that were sometimes inspired by models he had made in 1912–1914.

The Manufactory of Sèvres also made its contribution under the direction of Lechevallier-Chevig-

nard. He created a faience workshop, directed first by Avenard and then by Gensoli, and prepared for the 1925 Exhibition by employing a number of artists and decorators, not all of them of interest today. But they did include Rapin, Ruhlmann, Lalique, Dufy, Jaulmes, and the brothers Martel. Lechevallier-Chevignard organised exchanges with the Danish factory of Bing and Gröndahl, and opened the Sèvres workshops to Jean Gauguin, Paul's son.

Danish production had an important place at the 1925 Exhibition. The Royal Porcelain Manufactory of Copenhagen exhibited porcelain and sandstone wares with decoration under the glaze, tiger-ware, white porcelain and faiences. Statuettes by Kund Kyhn and high-relief hand-modelled pottery ware by Jais Nielsen attracted particular attention. Bing and Gröndahl also used a variety of techniques, producing soft-paste ware, porcelain with decorations under the glaze, porcelain with matt glazes, and sandstone. The porcelain of Jo Locher, Kai Nielsen and Jean Gauguin was the main attraction.

GLASS

Glassware, like pottery, was transformed around the turn of the century by such artists as Emile Gallé,

Eugène Rousseau, Dammouse and the Daum; and they too sought direct contact with the craft.

In the 1920s glassware was made by a variety of techniques and several original artists were active. The outstanding figure was René Lalique (1860–1945). At the 1900 Exhibition he had a great success with his jewellery, which he then gave up for glass. He adopted a thoroughly modern attitude towards his new craft, accepting mechanical production methods which allowed him to lower prices. His glass was sometimes tinted blue or brown; the shapes were simple, rational and, in the case of large vases, spheroid. The decoration consisted of motifs drawn from nature, and also featured female figures and children. Lalique made dinner services and perfume flasks, which made him known to the general public, as well as lighting equipment and such architectural features as fountains.

By contrast, Maurice Marinot (1882–1960) followed Gallé's example, treating glass as a handicraft. He began by designing classic forms and painting fashionable enamel decorations. But from 1923 he blew his own glass and used techniques of every kind to decorate it: cutting in depth with acids, large-surface cutting with the wheel, and cutting by flint. His patterns were mostly geometrical; and even those which were floral or naturalistic in inspiration

were geometricised. In 1927 Marinot began to model his vases and flasks in the furnace, inserting enamel or air bubbles between two layers of glass.

Besides these two innovators, several other artists deserve attention. Manzana-Pissarro decorated thin glass cups with enamel and gold, and Jean Luce and Marcel Goupy made table- and toilet-ware with floral decorations in monochrome or opaque enamels. The Daum, as indicated earlier, were important even in the 1900s. At Nancy they made plain glassware, tinted glass, double- or triple-layer glass, bulbous glass, gold inlaid or spangled glass, and cut glass. Both traditional elements and the strong influence of Marinot can be detected in their work.

The opaque, rough-grained, unpolished appearance of glass paste had appealed to many glass makers of the 1900s period: Gallé, Gros, Despret, Dammouse. At the beginning of the First World War, François Décorchemont was making pieces out of thick paste, and sticking them on to clay shapes which had been taken from the mould and polished after firing. He gave the material a horny appearance and geometrical decorations. Joachim and Jean Sala, two Catalan artists who had settled in Paris, used coarse-grained glass paste with brilliant blues and yellows in their decorative pieces.

The Baccarat crystal factory was founded in 1764.

It played its part in the development of the style of the 1920s by producing unusually shaped perfume flasks and tableware designed by Georges Chevalier. The most interesting pieces were undecorated, being distinguished by form alone.

Stained-glass attracted the attention of a few artists prepared to try to reintegrate the craft into modern life. Jacques Gruber designed stained-glass as an isolated decoration, whereas Louis Barillet made it totally subordinate to architecture, limiting its tones to grey, white and black, and reducing it to simple, geometrical shapes. He frequently worked with Mallet-Stevens, as did Jacques Le Chevalier, whom he had invited to collaborate in his workshop in 1920.

METAL

Iron played a very important part in furnishings of the 1920s. It was sometimes combined with other metals (such as copper) and used by Edgar Brandt, Szabo and Raymond Subes in the manufacture of railings, brackets, radiator-covers, fittings, candelabra, locksmiths' work, etc. The Fontaine pavilion in the 1925 Exhibition stressed achievements in this sphere, displaying the work of the sculptors Maillol

and Antoine Bourdelle as well as of such decorative artists as Groult, Süe and Mare, Montagnac, René Prou and Le Bourgeois.

Silver tableware followed the evolution of the other decorative arts. Although most metal work tended towards simple, geometrical forms in which decoration was practically eliminated, a few artists did succeed in expressing their personalities through the medium. They included Gérard Sandoz, Jean Serrière and Jean Puiforcat (1897–1945). Puiforcat has a claim to be regarded as the founder of modern silver work. He was a sculptor as well as a silversmith, and had a predilection for restrained forms and shiny surfaces, combining silver with ivory, wood, lapis-lazuli or jade, and sometimes unusual materials like crystal. Christofle was one of the most advanced of the big firms, manufacturing works by artists from other countries, including the Italian architect Gio Ponti and the Danish silversmith Fjerdingstad. The quality of Danish gold- and silver-ware had been revealed just before the First World War by Georg Jensen (1886–1935) who strove to restore qualities of craftsmanship to an art menaced by the machine.

Similar qualities were present in the works of the pewterer Maurice Daurat and the brass workers Claudius Linossier (1893–1953) and Jean Dunand. Dunand was born in Switzerland, near Geneva, in

1877. He approached brass work as a craftsman, handling the tools of the trade himself and developing various techniques, including *repoussé,* chasing, gold and silver inlays, patinas, lacquering and enamelling; sometimes he employed several different techniques in the execution of a single vase. Although his motifs were naturalistic before the war, after 1918 he adopted geometrical decoration and used a great variety of materials, including lead, nickel, steel and eggshell.

Jewellery of the 1920s was far removed from the fantastic creations of the 1900s, becoming simplified and restrained under the influence of Cubism. Only Raymond Templier and Jean Fouquet succeeded in giving it a note of distinction through the use of varied materials and colours.

LIST OF ILLUSTRATIONS

Page